JAPANESE COMICKERS

ジ ャ パ ニ ー ズ コ ミ ッ カ ー ズ

2

JAPANESE
ジャパニーズコミッカーズ
COMICKERS 2

Draw Manga and Anime like Japan's Hottest Artists

Edited by Comickers Magazine

COLLINS | DESIGN

An Imprint of HarperCollins*Publishers*

JAPANESE COMICKERS 2

First Japanese edition published in 2006 by:
Bijutsu Shuppan-sha Co., Ltd.
8F Inaoka Building
2-38 Kanda Jimbo-cho
Chiyoda-ku Tokyo
101-8417 Japan
Tel: 81 3 3234 2151
Fax: 81 3 3234 9451
http://www.bijutsu.co.jp/bss

First published in English in 2006 by:
Collins Design
An Imprint of HarperCollins*Publishers*
10 East 53rd Street
New York, NY 10022
Tel: (212) 207-7000
Fax: (212) 207-7654
collinsdesign@harpercollins.com
www.harpercollins.com
with the rights and production arrangement by
Rico Komanoya, ricorico, Tokyo, Japan

Distributed throughout the world except Japan by:
HarperCollins*Publishers*
10 East 53rd Street
New York, NY 10022
Fax: (212) 207-7654

Editing: Keiko Yamamoto, Yuri Okamoto, Rico Komanoya
Typesetting: Far, Inc. + Rie Tago (Souvenir Design)
Book Design and Art Direction: Atsushi Takeda (Souvenir Design)
English Translation: Keiko Kitamura, Alma Reyes Umemoto
Copy-editing: Alma Reyes Umemoto
Production: Rico Komanoya (ricorico)

Library of Congress Control Number: 2005932702

ISBN-10: 0-06-083330-0
ISBN-13: 978-0-06-083330-5

Printed in China by Everbest Printing Co., Ltd.

Second Printing, 2006

Contents

Introduction

Around the world, Japanese manga has become more and more popular. Manga artists have made their work come alive, not just on paper, but in cartoons on television and in movie theaters, in Japan and abroad.

The manga and anime markets in Japan have become increasingly progressive, with convention giving way to experimentation. Young artists tend to develop their own personal styles instead of being dominated by tradition. For instance, one popular type is the anime style known as "Moe," or "the ideal girl." These very popular images are of cute young girls with huge eyes. There are many other genres of Japanese animation, some of which you will find in this book.

It's not just Japanese artists who are drawn to the flourishing world of Japanese manga and anime. Young artists from other Asian countries, whose sensibilities are similar to those of the Japanese, are making a contribution as well. Some of the Korean artists featured in this book started their careers in the game-software field and have now expanded their horizons. At first glance, their style of expression appears similar to that of the Japanese, but they also bring fresh ideas to the world of manga that in turn inspire Japanese artists.

The growth of the Internet has been one of the most exciting developments in comickers art, helping break down barriers between nations. Young manga and anime fans can now enjoy viewing marvelous works from all over the world. Differences in nationality mean nothing to these fans; all they care about is whether a picture is wonderful or not. Consequently, Japanese manga and animation have attracted worldwide attention and have drawn many talented creators from all over the world to Japan. At the same time, thanks to the Internet, Japanese artists are spreading their wings across the globe.

Japanese Comickers 2 introduces outstanding works of young artists who are taking Japanese animation styles in novel directions. This book is an omnibus of today's exciting and stimulating artists from Japan, Taiwan, and Korea. We hope you enjoy their fresh, brilliant work.

Comickers Magazine, Editorial Desk
Keiko Yamamoto

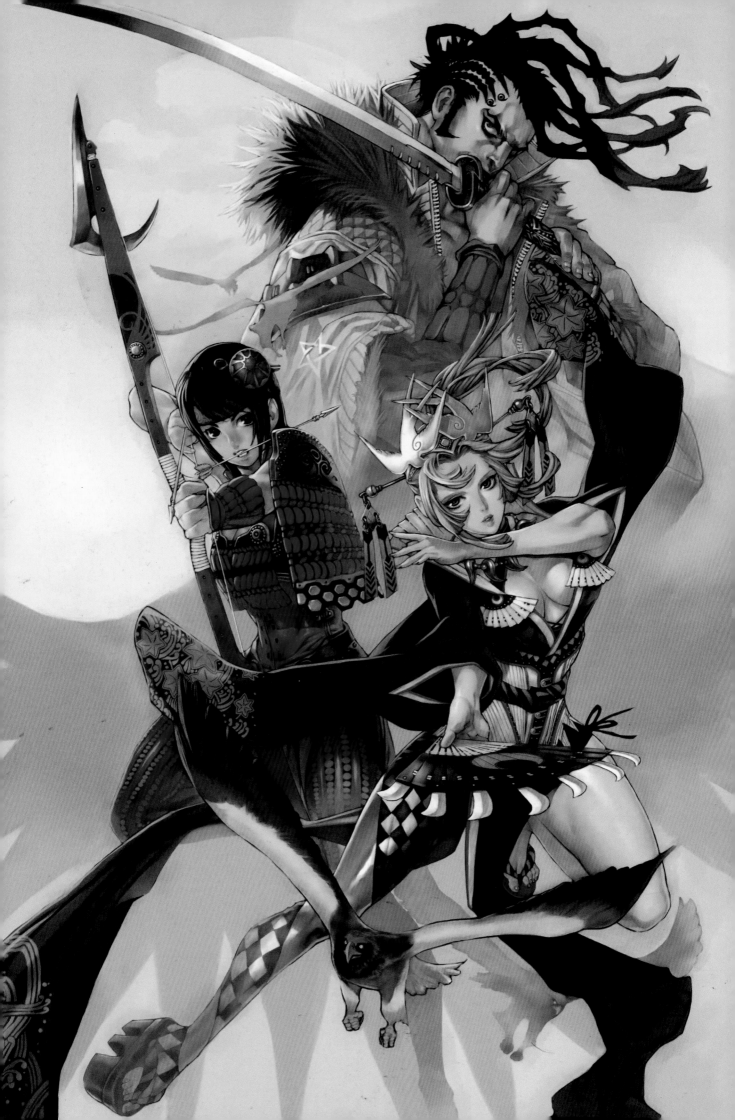

Shigeki
Maeshima

前嶋重機

Shigeki Maeshima's work is both dignified and stylish, reflected in his masterful painting skill and his strong sense of composition. Not just an illustrator, he is also the creator of vigorous, full-color manga. His representations of stunning, beautiful women are especially popular. Maeshima's painting technique masterfully depicts light reflecting on surfaces and subtle variations in texture. Without doubt, his work can be thought of as "fine art."

Shigeki Maeshima

Date of birth	: February 6, 1974
Gender	: Male
Place of birth	: Wakayama, Japan
Educational background	: Sozosha College of Design

Working tools

Main computer	: Shop brand PC
OS	: WINDOWS XP
CPU	: Pentium4 3.2G
Applications	: Photoshop 5.0J, Painter 5.5J
Memory	: 1024MB
HDD	: 120GB

Favorite artists

Mike Mignola, Frank Frazetta

Published works

Mushinin (Insect Ninja) series, by Hideyuki Furuhashi, Tokuma Shoten Publishing Co., Ltd., 2004
DRAGON FLY in *Robot 1*, full color comic and art book, Wanimagazine Co., Ltd., 2004

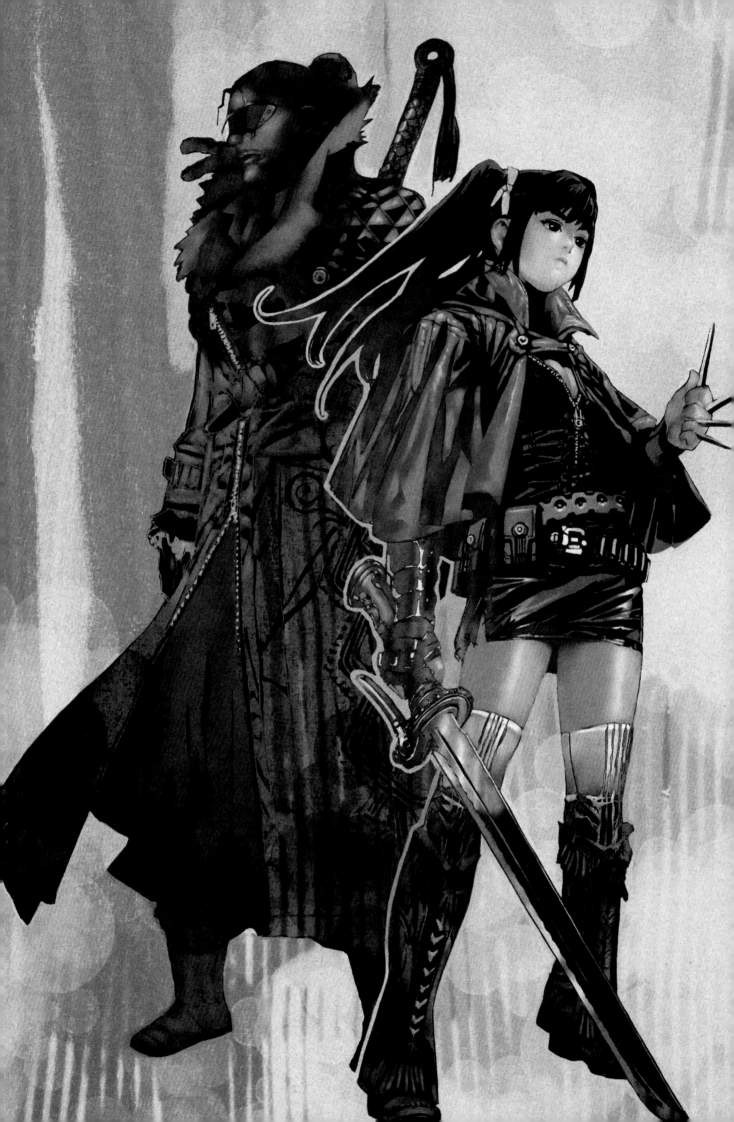

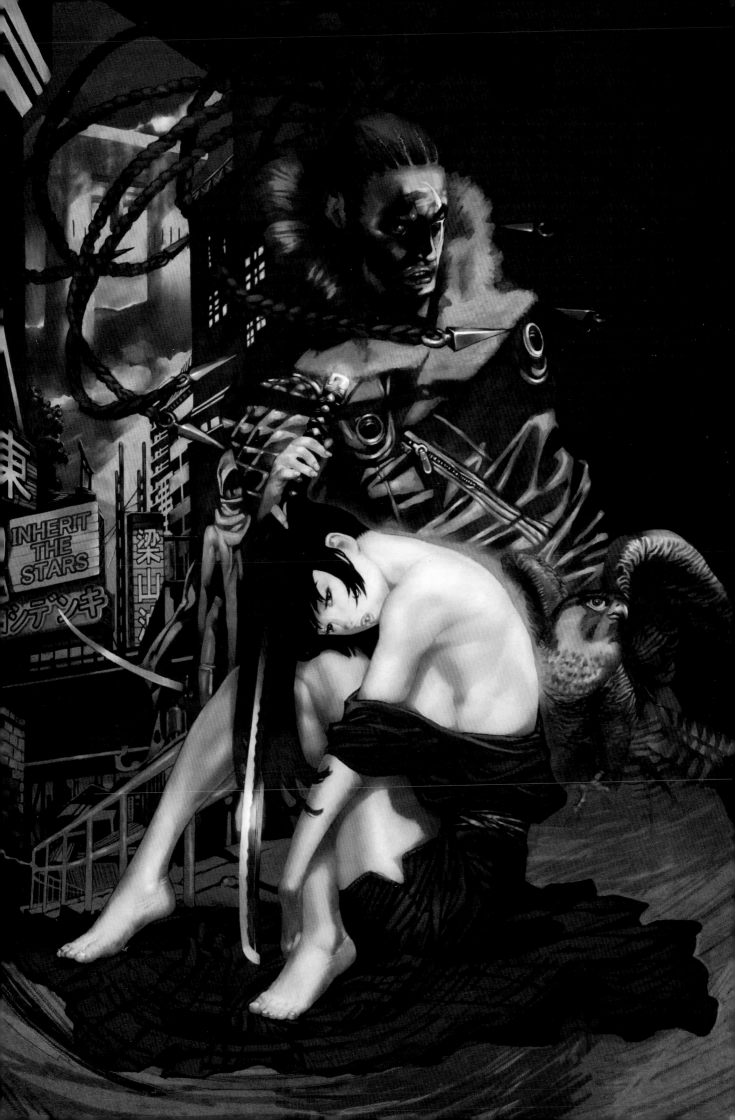

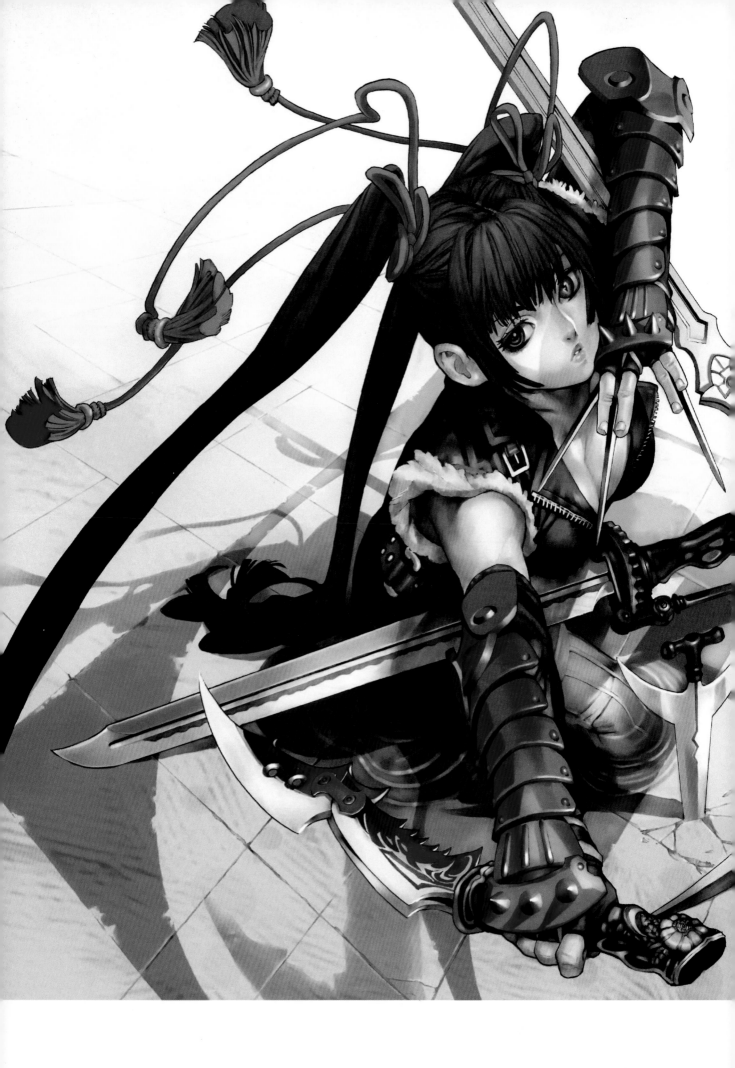

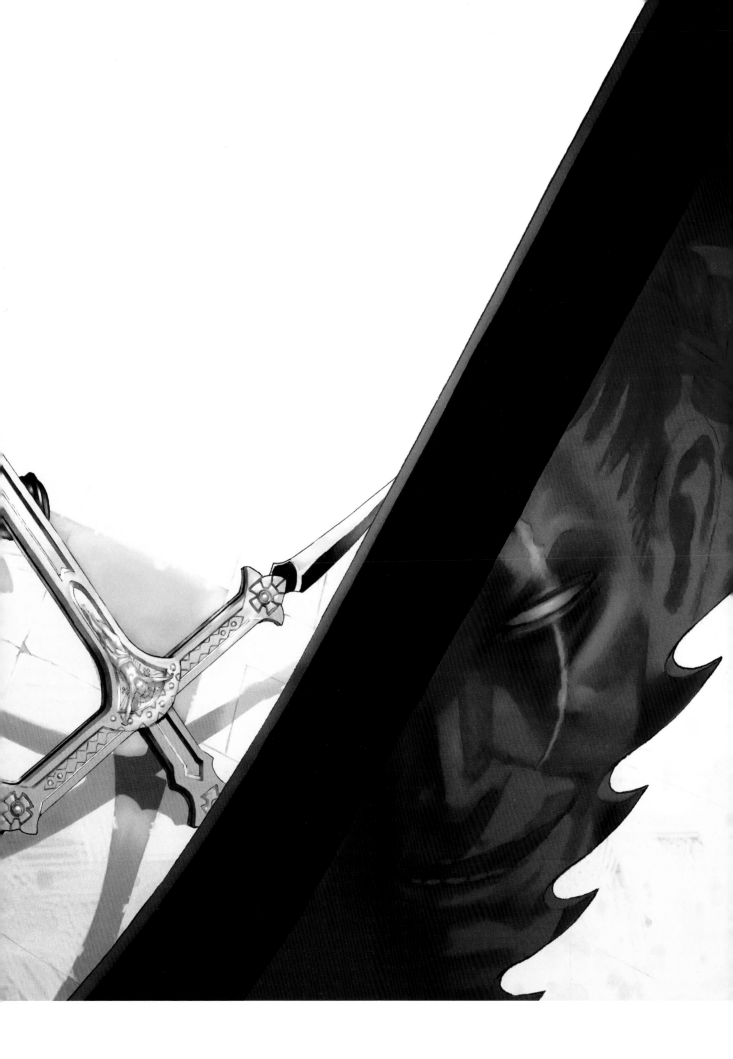

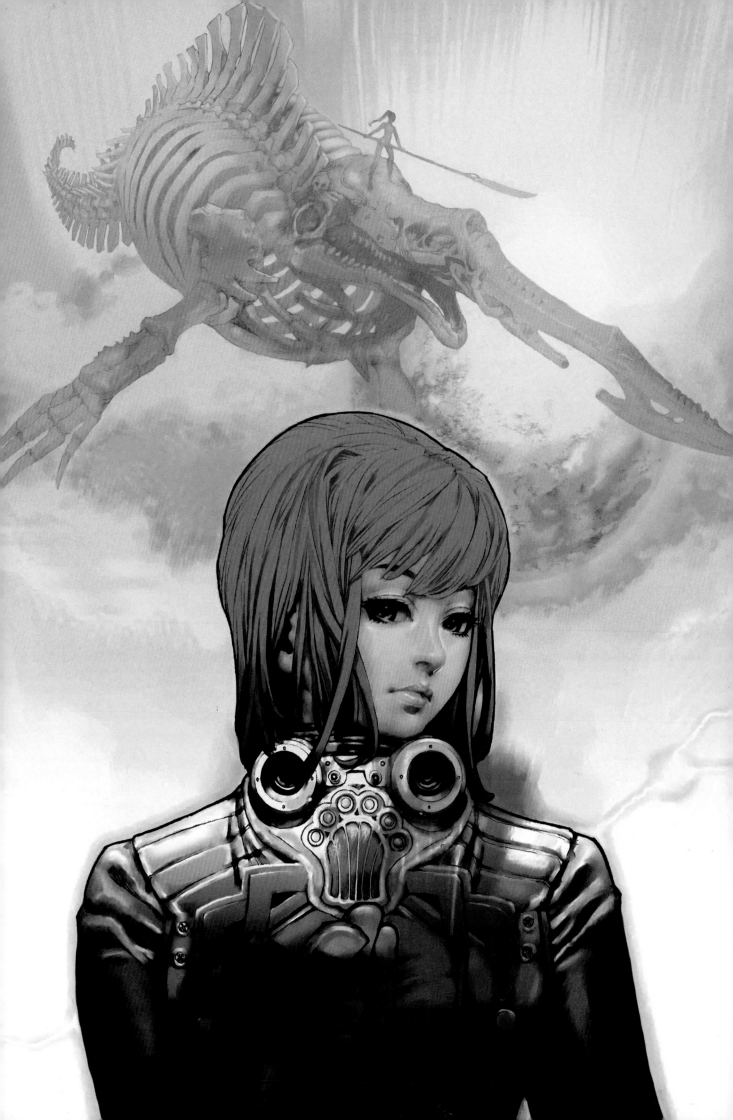

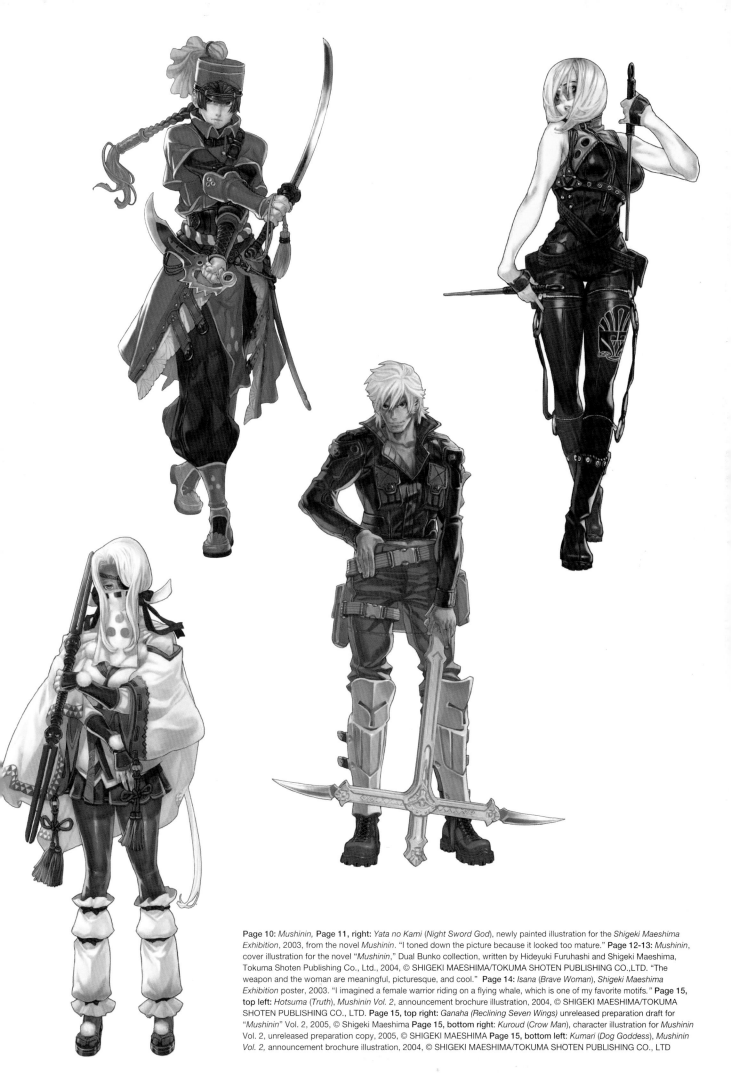

Page 10: *Mushinin,* Page 11, right: *Yata no Kami (Night Sword God)*, newly painted illustration for the *Shigeki Maeshima Exhibition*, 2003, from the novel *Mushinin*. "I toned down the picture because it looked too mature." Page 12-13: *Mushinin*, cover illustration for the novel *"Mushinin,"* Dual Bunko collection, written by Hideyuki Furuhashi and Shigeki Maeshima, Tokuma Shoten Publishing Co., Ltd., 2004, © SHIGEKI MAESHIMA/TOKUMA SHOTEN PUBLISHING CO.,LTD. "The weapon and the woman are meaningful, picturesque, and cool." Page 14: *Isana (Brave Woman)*, *Shigeki Maeshima Exhibition* poster, 2003. "I imagined a female warrior riding on a flying whale, which is one of my favorite motifs." Page 15, top left: *Hotsuma (Truth)*, *Mushinin* Vol. 2, announcement brochure illustration, 2004, © SHIGEKI MAESHIMA/TOKUMA SHOTEN PUBLISHING CO., LTD. Page 15, top right: *Ganaha (Reclining Seven Wings)* unreleased preparation draft for *"Mushinin"* Vol. 2, 2005, © Shigeki Maeshima Page 15, bottom right: *Kuroud (Crow Man)*, character illustration for *Mushinin* Vol. 2, unreleased preparation copy, 2005, © SHIGEKI MAESHIMA Page 15, bottom left: *Kumari (Dog Goddess)*, *Mushinin* Vol. 2, announcement brochure illustration, 2004, © SHIGEKI MAESHIMA/TOKUMA SHOTEN PUBLISHING CO., LTD

STEP-BY-STEP

01 This shows the rough draft. I like *chanbara* (sword fights), so I often choose Japanese motifs for my theme. I imagined a samurai-themed story with a slightly cosmopolitan atmosphere to create the characters.

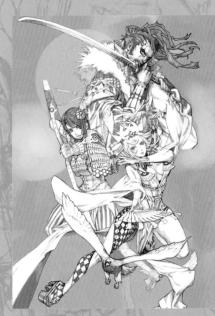

02 I cleaned up the rough drawing using a pencil, and changed the position of the samurai character at this stage. Then, I painted only the shadow, first directly on the rough drawing using markers. This technique is called the "grisaille" method, which is often applied to save time, and to give an idea of the finished work.

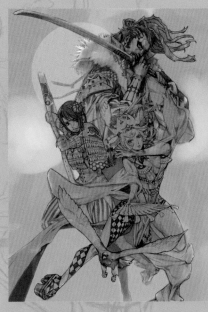

03 I emphasized the characters in front by shading the character behind them in the background to show perspective.

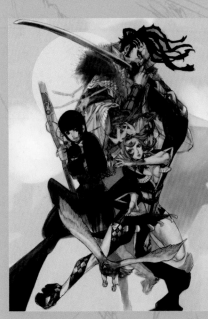

04 This shows the finished base. I stopped here because I was able to grasp the direction of my drawing, and to visualize the completed outcome.

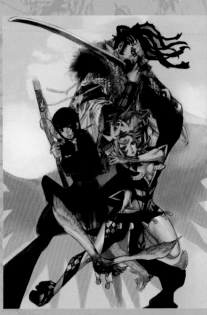

05 I changed to a brush tool to paint the characters' skin and hair. I set the light source and applied a brighter color gradually. Later, after having become aware of the reflection of the surrounding light, I painted the shadow.

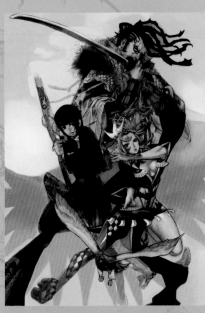

06 This shows the stage of painting the girl's costumes. Metal reflects light, so I increased the contrast. Cloth absorbs and diffuses light, so I decreased the contrast to convey the texture of the materials.

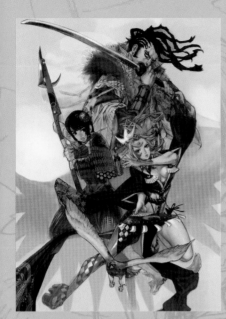

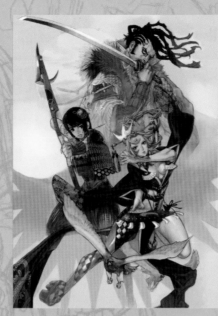

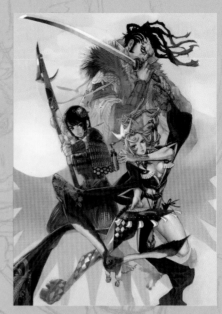

07 I painted the armor part by part, and applied a brighter color on the darker base.

08 Again, I emphasized the characters in front by shading the character behind them in the background to show perspective.

09 I added color to the eagle and placed highlights on each character to give a spatial effect.

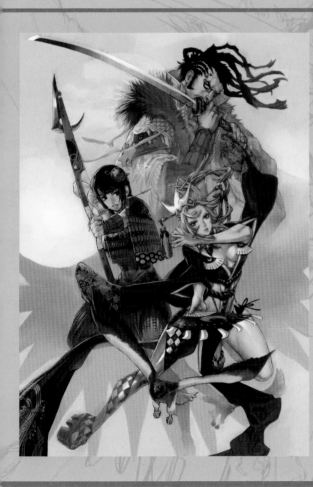

10 Finally, I completed the picture by using Photoshop's Noise filter to make the surface grainy, and adjusted the color with the Color Balance control.

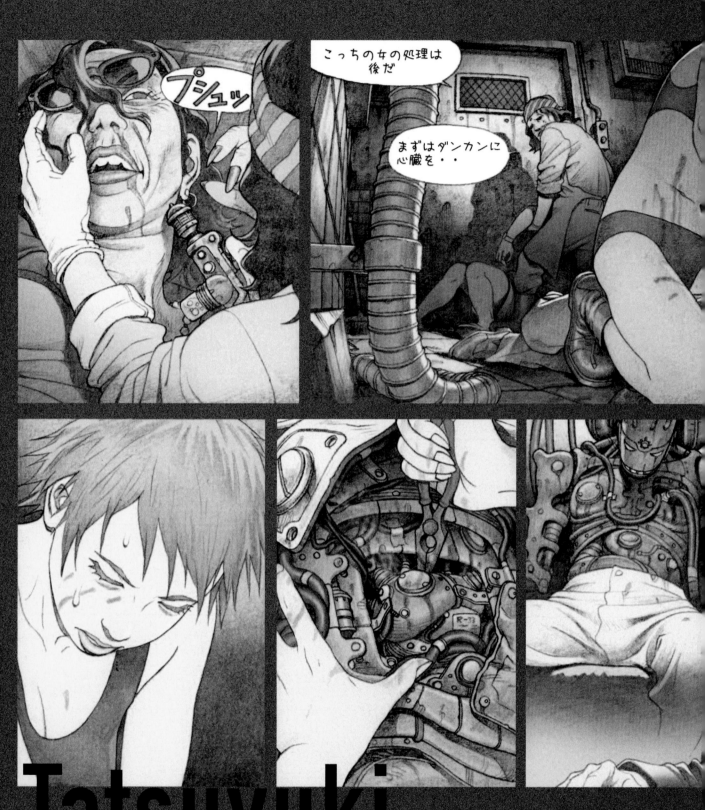

Tatsuyuki Tanaka

Tatsuyuki Tanaka

brilliantly overlaps layers of color, creating realistic renditions of the atmosphere. Each illustration is composed of varied hues of one color, which gives them a distinct, monochromatic look. Using these limited color combinations, he makes unique, transparent pictures.

As a professional animator, Tanaka conveys a marvelous sense of perspective in his drawings. He paints the background in a single line sketch without any hesitation.

Tatsuyuki Tanaka

Date of birth	: May 25, 1965
Gender	: Male
Place of birth	: Fukuoka, Japan
Educational Background	: High school dropout

Working tools

Digital

Main computer	: Macintosh
OS	: OS X
CPU	: PowerPC G5 1.6Ghz
Applications	: Photoshop 5.5
Memory	: 1.25GB
HDD	: Internal hard disk drive 160GB(Seagate)
Printer	: EPSON PM-770C
Scanner	: EPSON GT-7600S

Hand Drawing and Painting

Paper	: A4 copier paper
Coloring	: Pentel GRAPH1000 0.3mm & 0.9mm, Tombow MONO rubber eraser

Favorite artists

Katsuhiro Otomo, Imiri Sakabashira, Akiko Endo, Rokuro Taniuchi

Published works

CANNABIS WORKS: Asukashinsha Co., 2003
AKIRA: original animation
Toujin-kit direction: art and animation
Linda3, *Linda3 Again*: game character design
NTT East Japan SMAP commercial/Gatchaman edition: storyboard
LEBRON JAMES IN CHAMBER OF FEAR,
Nike-CM: effects, art and image production

田中達之

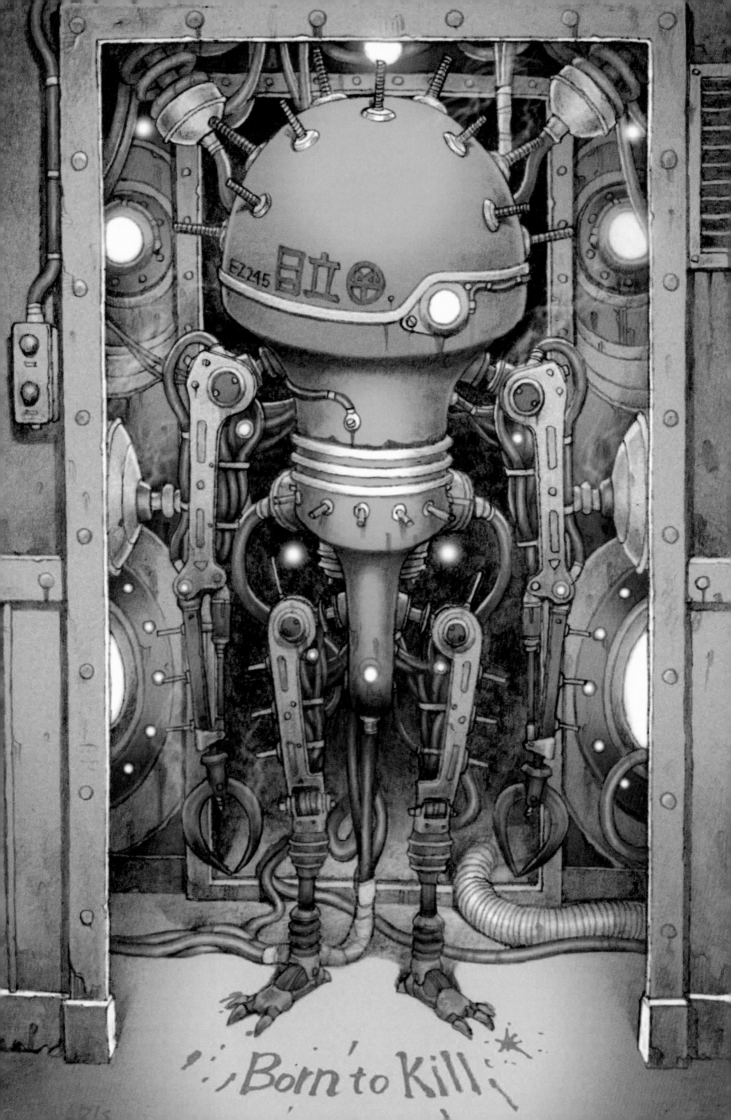

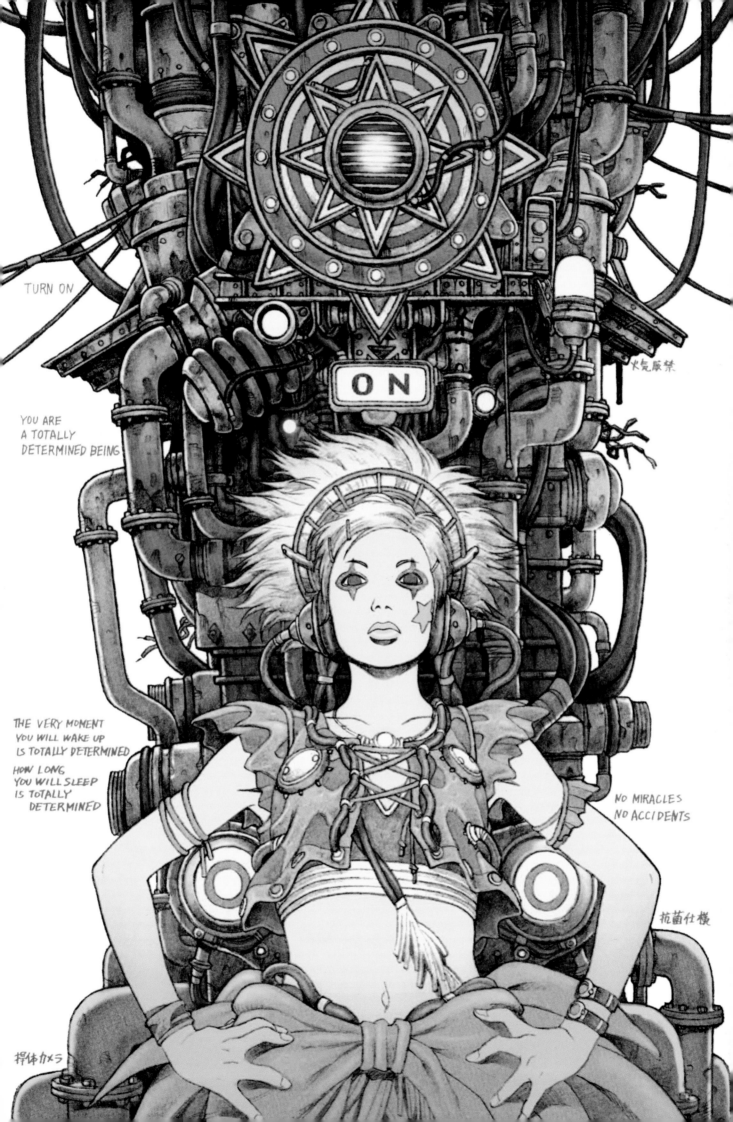

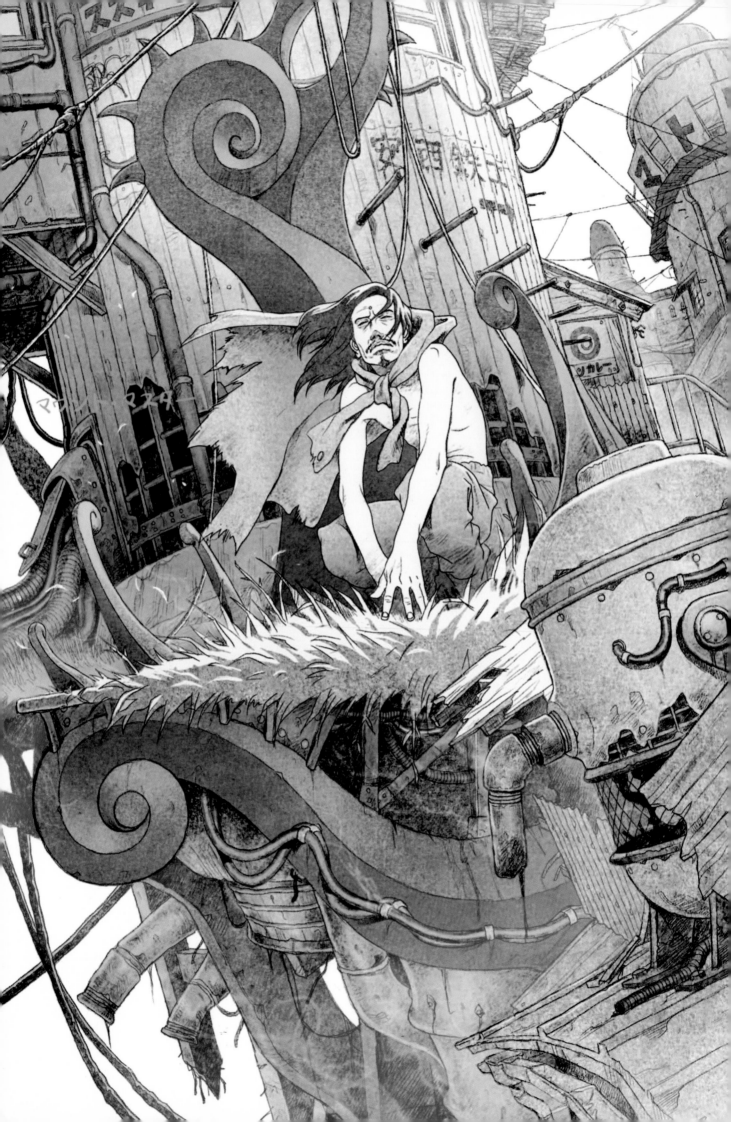

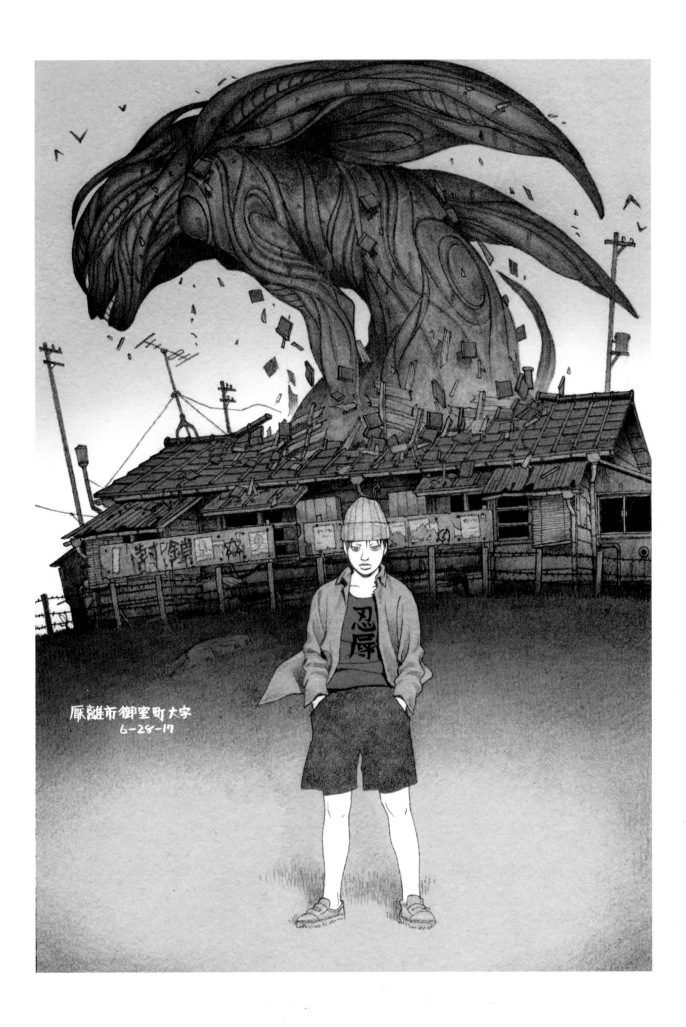

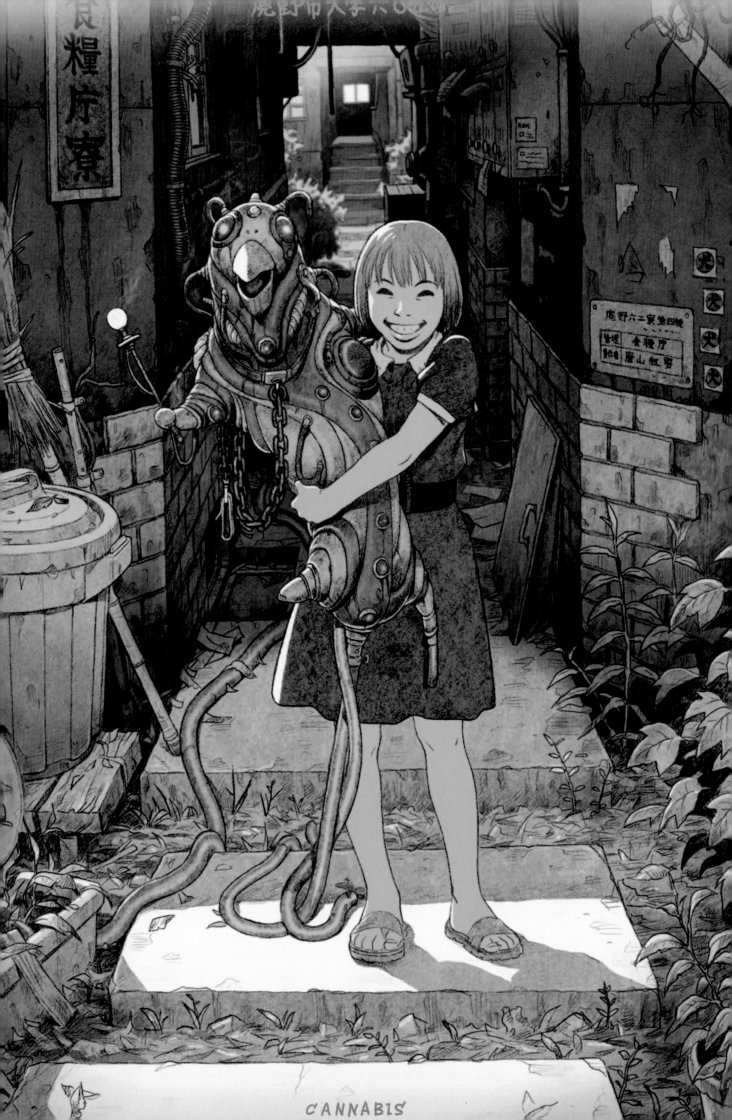

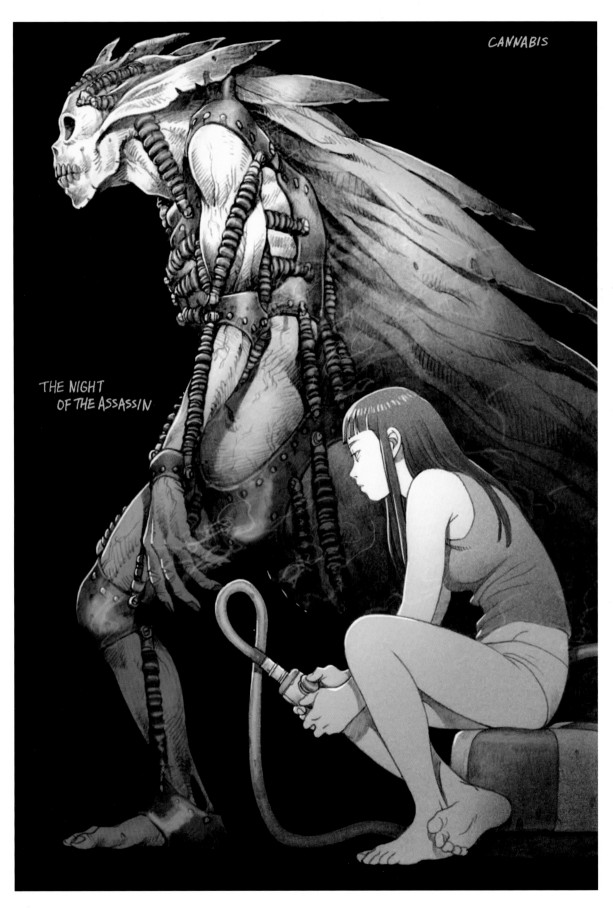

CANNABIS

THE NIGHT
OF THE ASSASSIN

STEP-BY-STEP

01 First, I drew a rough sketch. Then, I shaded it so that I could check the complete image balance more easily.

02 I made a clean copy of the sketch using pencils. I drew the small objects, background, and all the other details of the character. Then, I scanned the drawing.

03 I darkened the pencil-shaded area by adjusting the level of the scanned illustration data. Then, I added a new layer to create the outer frame.

04 To adjust the color balance, first, I spread a yellow tint thinly with Multiply Mode. Then, I added a new Adjustment Layer over it and increased the cyan shade. This determined the basic color of this picture. Afterwards, I filled in the black background with Multiply Mode and erased the highlights.

05 I applied color to the hair and clothes of the character. I painted them considering their overall balance and color.

06 To create the background tone, I added black gradation to the background and to the character in order to show perspective.

026

07 To add color balance, I used the Adjustment Layer control to redden the entire image filled with black, then, I applied a white tint. This process also added a reddish tone to the light source and the fine rust.

10 I multiplied the monochromatic noise by 22%, to make the whole image look grainy.

08 I finalized the picture by adding a white effect, and applying other colors to the detailed parts. I edited the picture by adjusting the colors.

11 To complete the picture, I did the typesetting using the freeware font, "Aqua." I used handwritten fonts for the balloons.

09 I merged all the layers once.

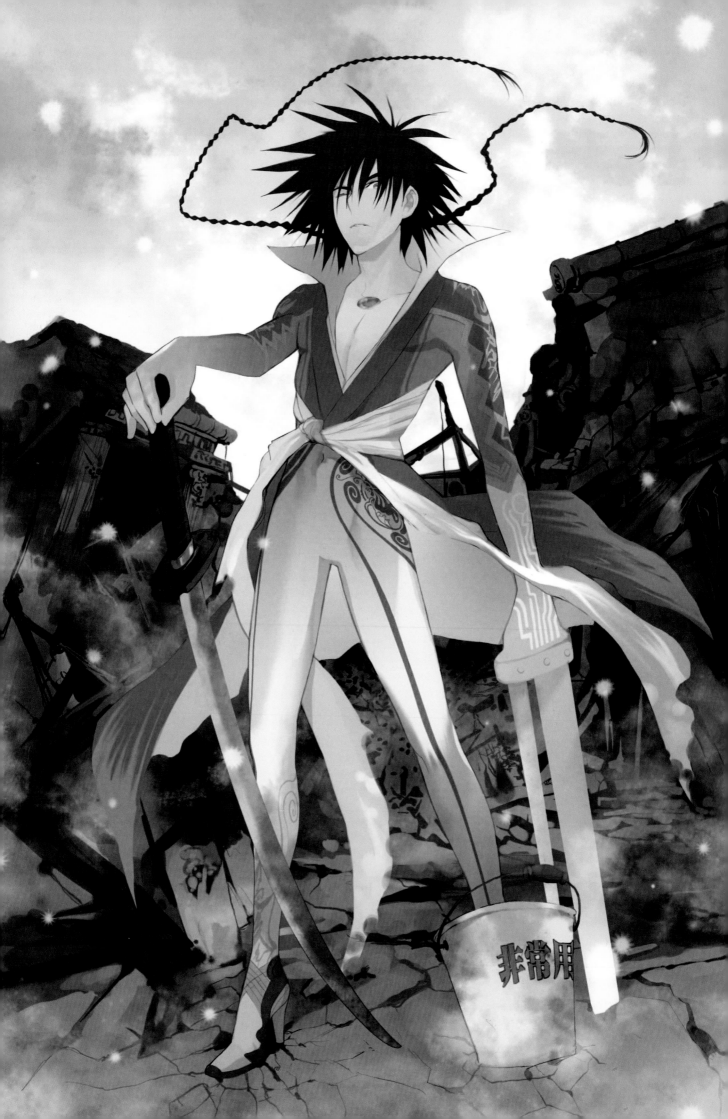

Waka Miyama

深山和香

Waka Miyama is finely attuned to current trends and fashion, yet she maintains her own identity. The "Moe" character (the "ideal girl" in Japanese anime) inspires much of her work. She is heavily influenced by the element of time, which can be seen in her illustrations. Miyama uses Photoshop entirely to create her drawings.

Waka Miyama

Gender	: Female
Place of birth	: Japan
Educational background	: Kyoto Saga University of Arts graduat
Web site	: http://oniqu.jp

Working tools

Digital

Main computer	: Windows
OS	: Windows 2000
CPU	: AMD Athlon64 3000+
Applications	: Photoshop 7.0
Memory	: 1Ghz
HDD	: external hard disk drive 200GB

Favorite artists

Joji Morikawa, Kingu Gonta, Takuji Kusanagi, Kaoru Fujita

Published works

Rocket Starter magazine, Special No. 4, Kodansha Ltd., 2005
GAINAX Official Homepage Top Illustrations, Gainax, 2005
BAD x BUDDY series, Fujimi Shobo, 2005; cover design

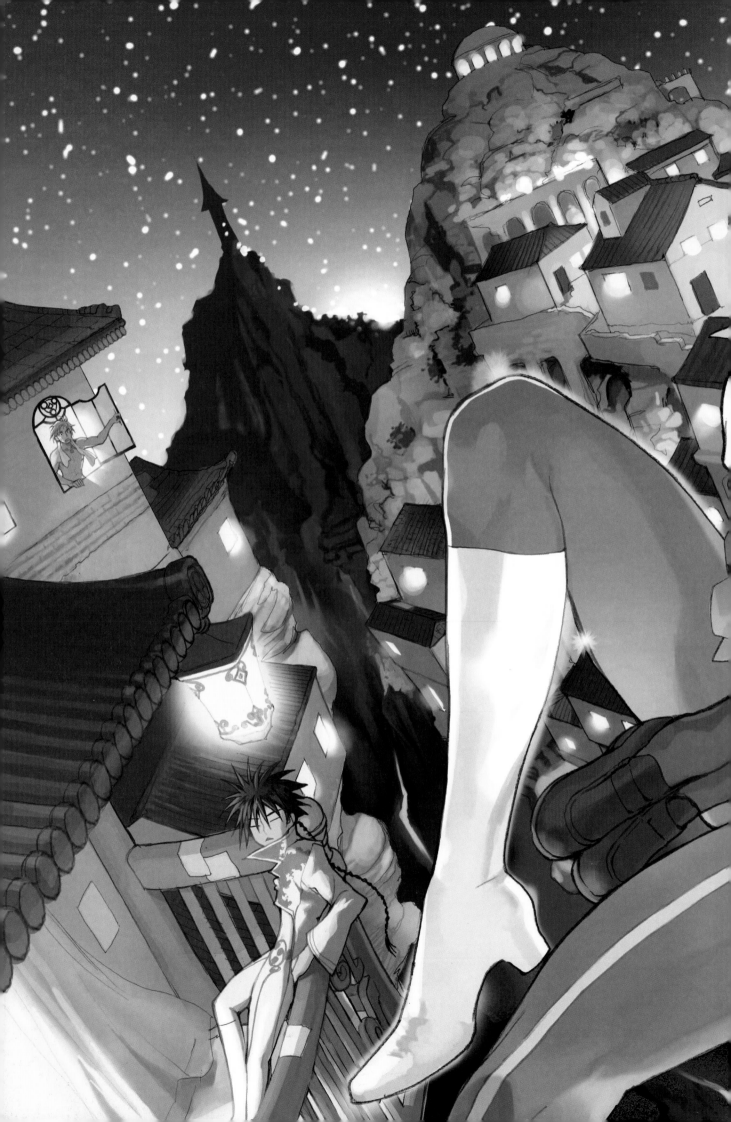

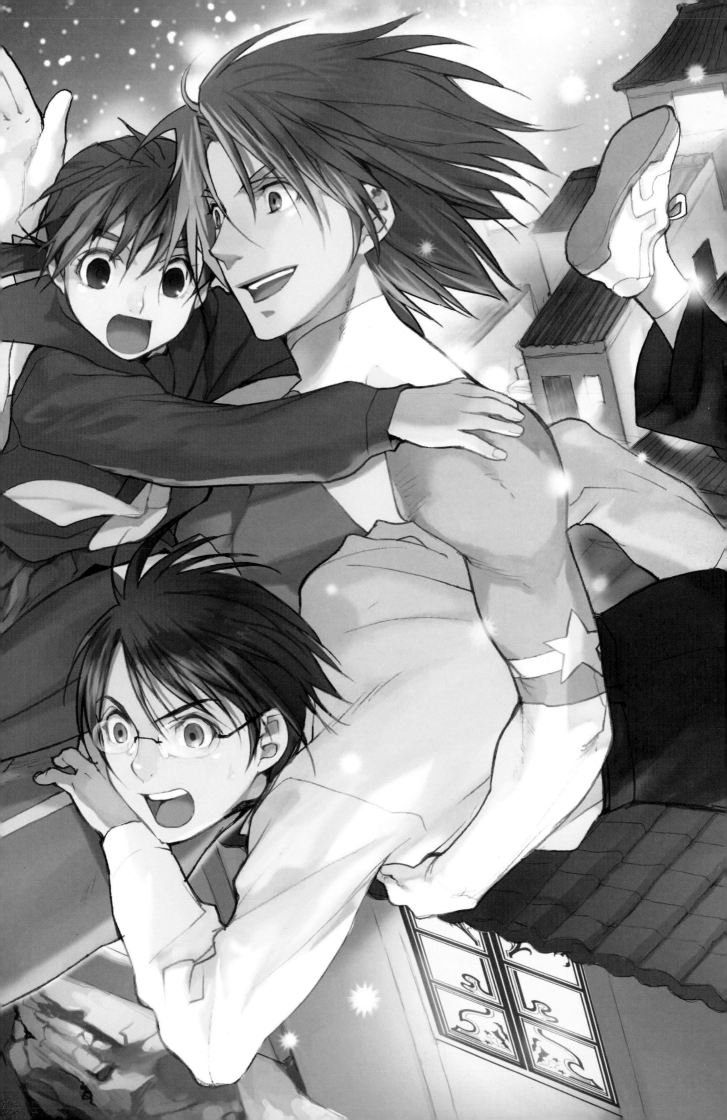

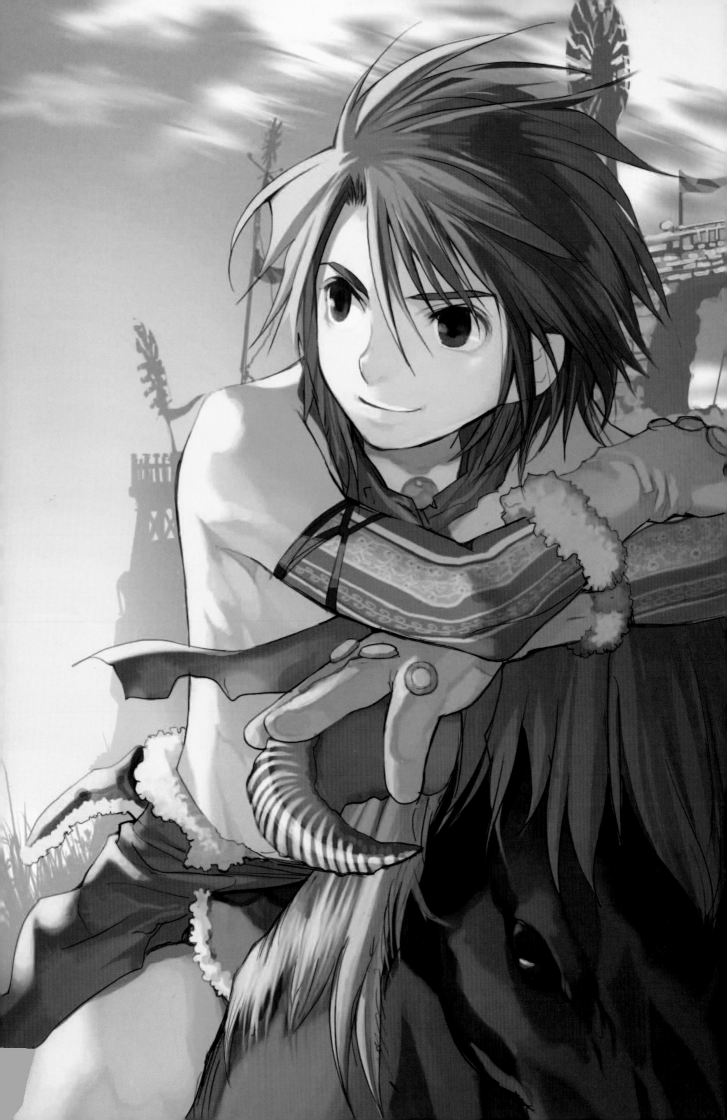

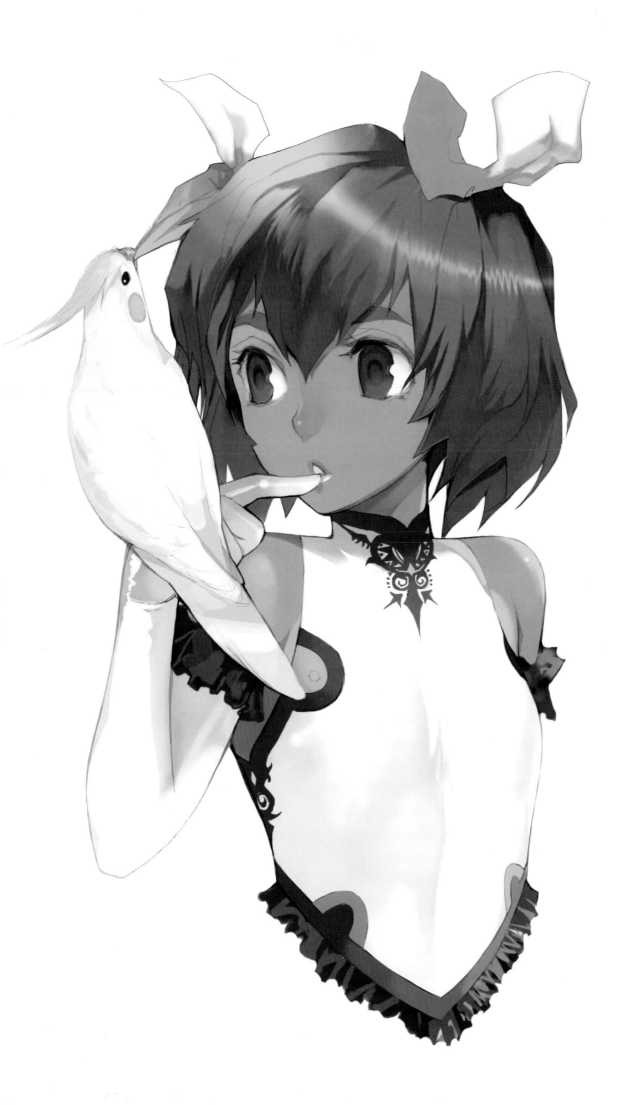

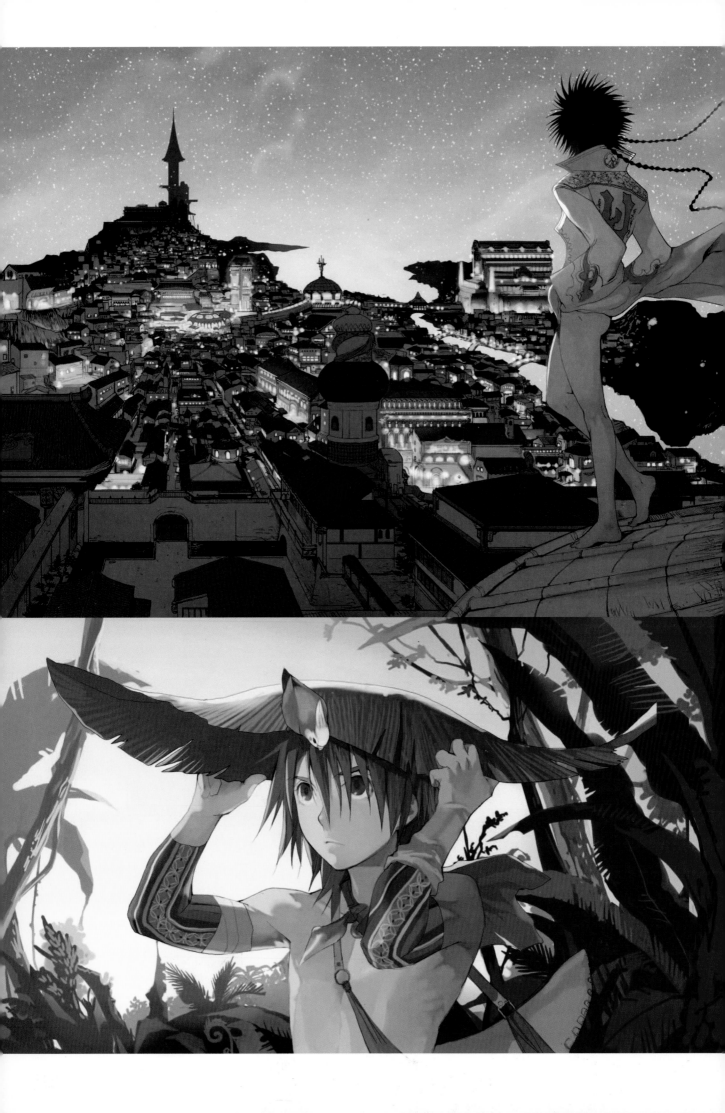

Page 30-31: *Drupha no Yoru 2* (*Night of Drupha Vol. 2*), COMITIA 72 flyer clip, COMITIA executive committee, May 2005, © 2005 COMITIA Co., Ltd. All rights reserved. "I projected a bright mood for the night scene in this advertising poster. I intended to show the movements by giving the characters a rich expression." Page 32: *Shonen Marin* (*Marine Boy*), private collection, September 2004. "I set the time just before sunset, and tried to express the dry air of the grassland." Page 33: *Ruru to Inko* (*Lulu and the Parakeet*), private collection, October 2004. "I applied the black-and-white motif. The parakeet is my favorite bird. I paid careful attention to the girl's innocent expression." Page 34, top left: *Ake no Tesra 2* (*Tesla at Dawn Vol. 2*), coterie magazine "Shinen no Kujira" (*Whale in the Abyss*), inside cover, August 2004. "I always depict 'time' as the theme for my illustrations. Here, I used 'dawn' as one of my expression patterns." Page 34, bottom left: *Sorosoro Kaero* (*It's About Time to Go Home*), private collection, October 2004. "Sunset is my favorite time." Page 35, top right: *Kitsune Mimi* (*Fox Ears*), TECH GIAN March 2005 issue, Next Creator Museum, Enterbrain, Inc., © 2005 WAKA MIYAMA, Published by Enterbrain, Inc. "The motifs were plums and butterbur flower stalks. I used the watercolor painting style to make effective use of the white background." Page 35, bottom left: *Under the Cherry Blossam*, TECH GIAN March 2005 issue, Next Creator Museum, Enterbrain, Inc., © 2005 WAKA MIYAMA, Published by Enterbrain, Inc. "A Weeping cherry, I always enjoy drawing flowers since it in creases the variety of my drawing expression."

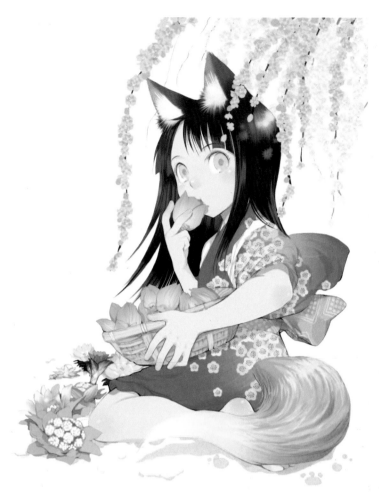

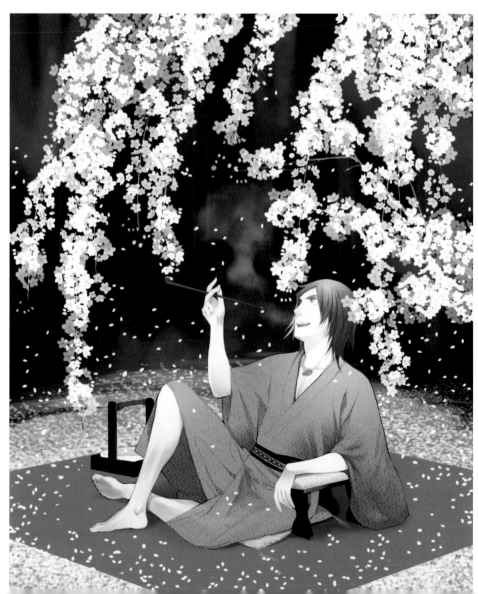

STEP-BY-STEP

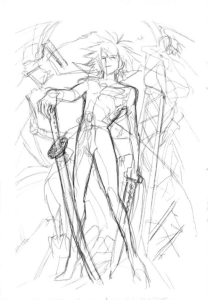

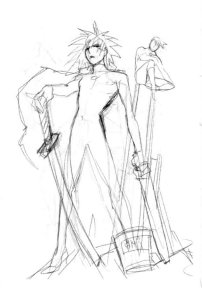

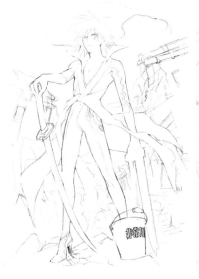

01 This is a rough sketch of the character I often draw in a comic series called, "Whole Body Tights 'Rocket Starter'."

02 I modified the picture while considering the entire composition that was based on the rough sketch. I arranged the lines after deciding on the direction of the composition.

03 I removed the character from the back of the rough sketch, and drew a background that conveyed the atmosphere of a Japanese fantasy. I thought that an image of a hubristic or arrogant man who stands among the ruins would be suitable for this piece of work. After deciding on the entire composition, I traced it roughly without drawing in detail.

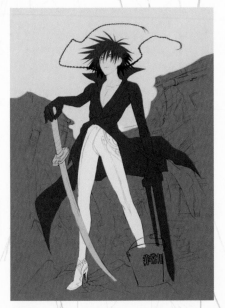

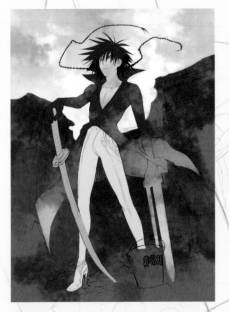

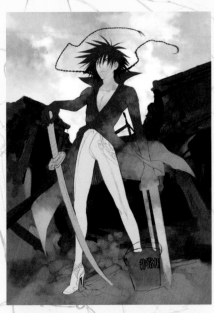

04 I used Photoshop for the entire process—color-coding the hair, skin, clothes, background, and other elements part by part.

05 I colored the image roughly, and overlaid a layer on the part that was colored flatly in the previous step. Then, I added a contrasting density while considering the shade and the shadow.

06 I painted the background while thinking of the shaded parts, and colored the character at the same time.

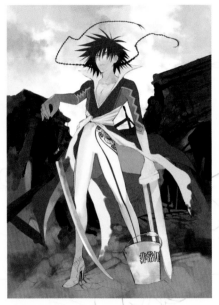

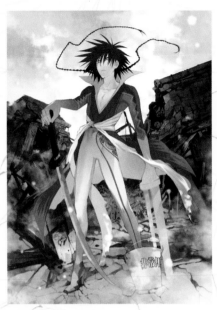

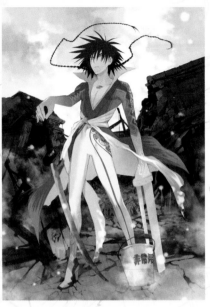

07 I showed details in the character's clothes, such as in the patterns on his sleeves and waist, and added to them Japanese decorations.

08 I detailed the ruins and the cracks in the ground, and adjusted color to them, while trying to maintain balance with the character.

09 I added some patterns and painted the character's shoulders, left arm, and legs. I applied the last color adjustment by considering the balance between the background and the character, and then, I erased all the line drawings in the background.

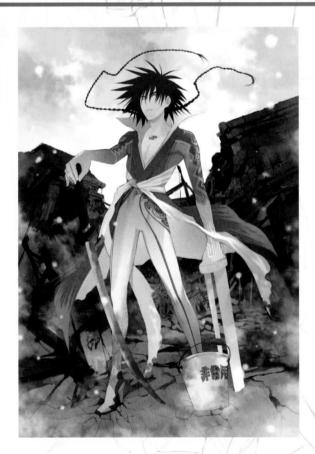

10 I modified further details, such as the protruding lines and the character's facial expression. Finally, I completed the work after adding a highlight effect.

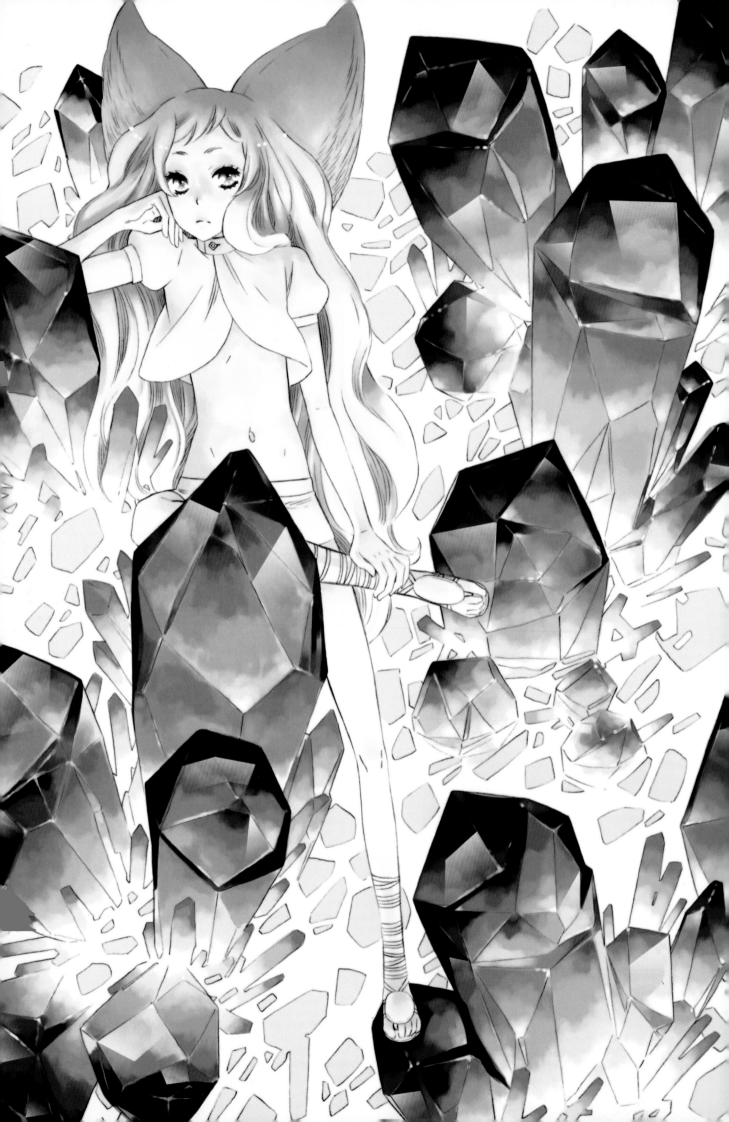

Lily Hoshino

星野リリィ

The comic artist Lily Hoshino's unique worldview centers on fantasy and characters that have distinctive personalities, as seen in her many girls' comics. Her works are stylish and sometimes sweet, and in her simple line drawings, she creates a cute, pop modern fantasy world of animation.

Lily Hoshino

Date of birth	: December 17
Gender	: Female
Place of birth	: Nagano, Japan
Educational background	: Shiraumegakuen Junior College graduate

Working tools

Mai

Main computer	: Macintosh
OS	: OS X
CPU	: 1GHz Power PC G4
Applications	: Photoshop 7
Memory	: 512MB
HDD	: 80GB

Favorite artists

Akira Yasuda, Akemi Takada

Published works

Toritsu Maho Gakuen (Tokyo Metropolitan School of Sorcery), Kaiousya Co., Ltd.
Super Double, Gentosha Comics Inc. *Hanamuko-san* (Mr.Groom), Houbunsha Co., Ltd.

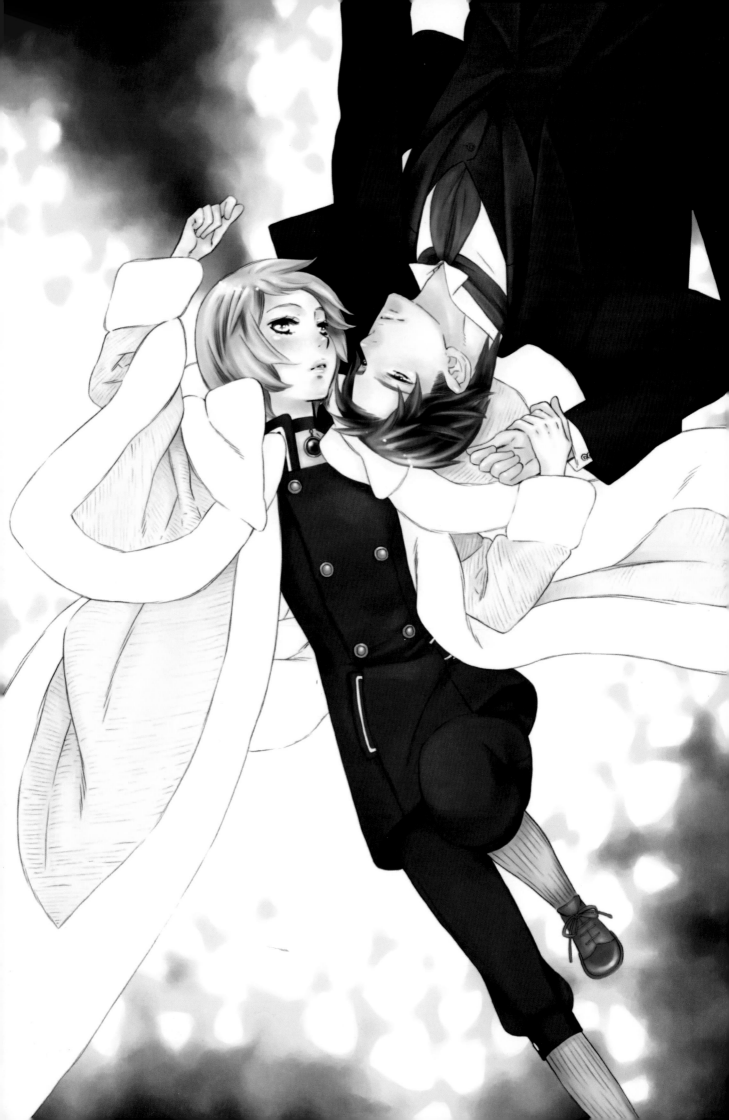

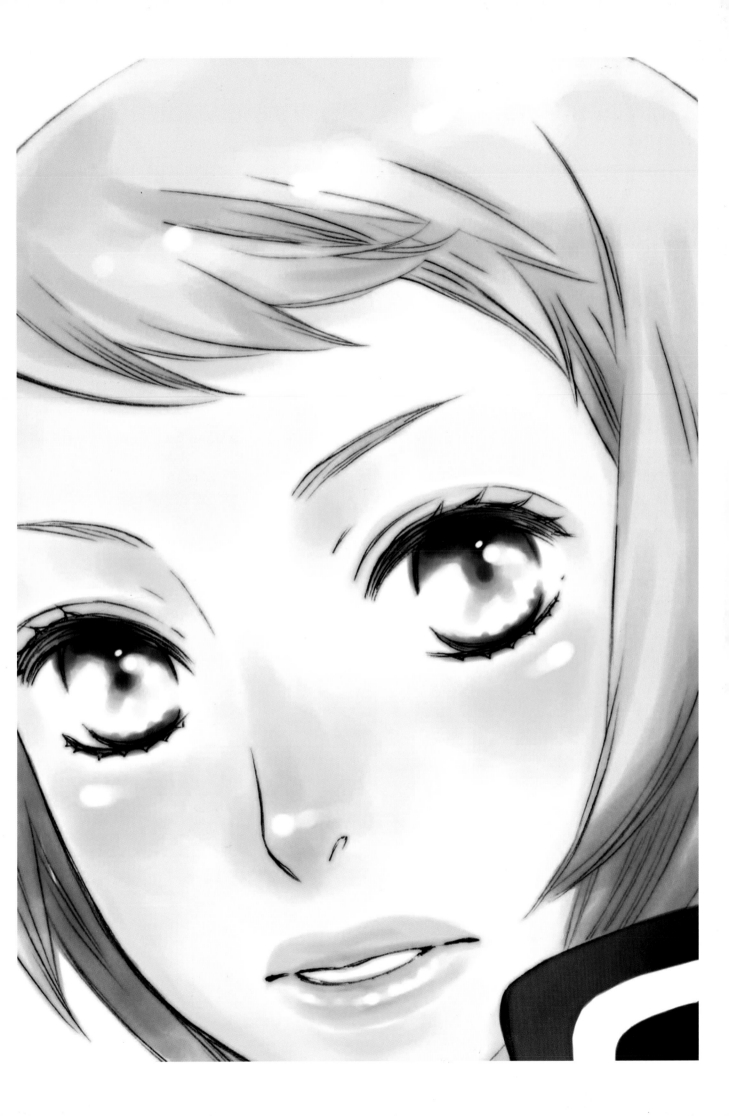

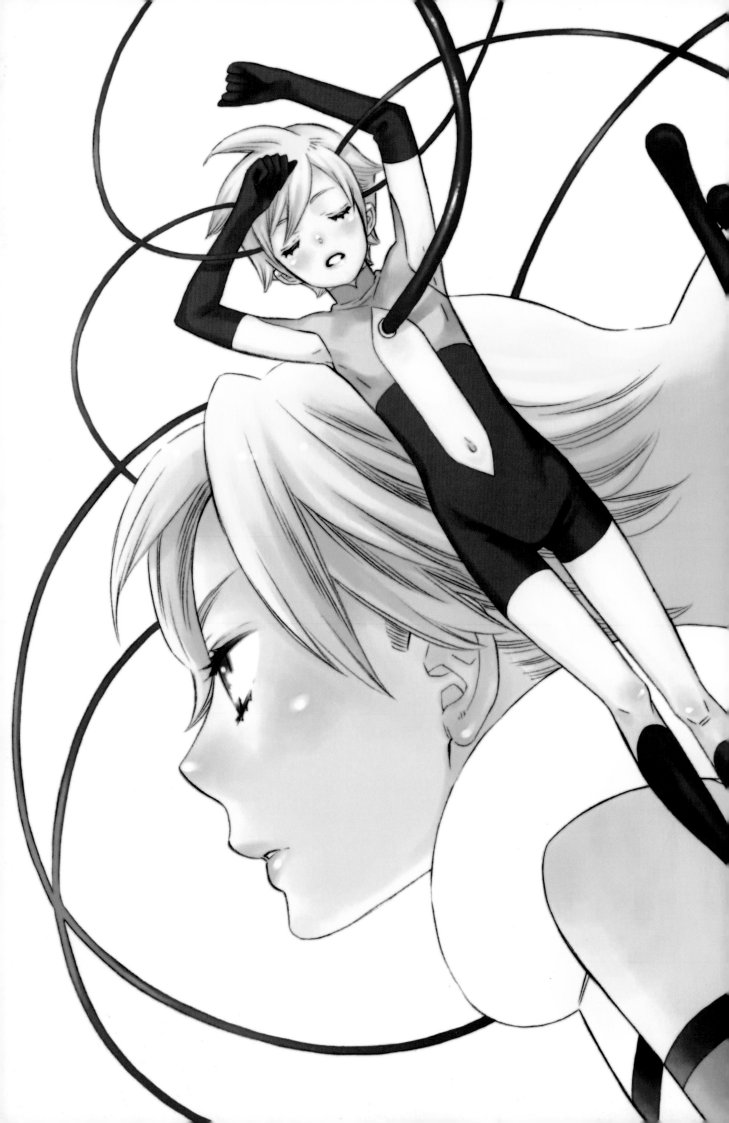

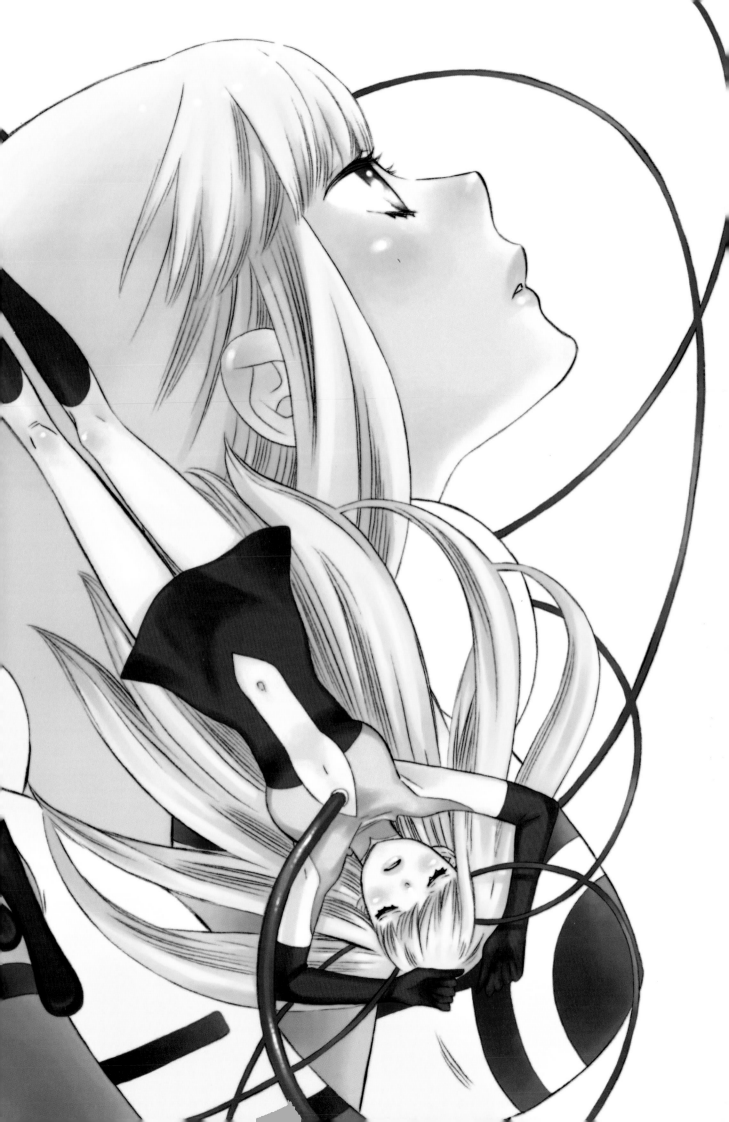

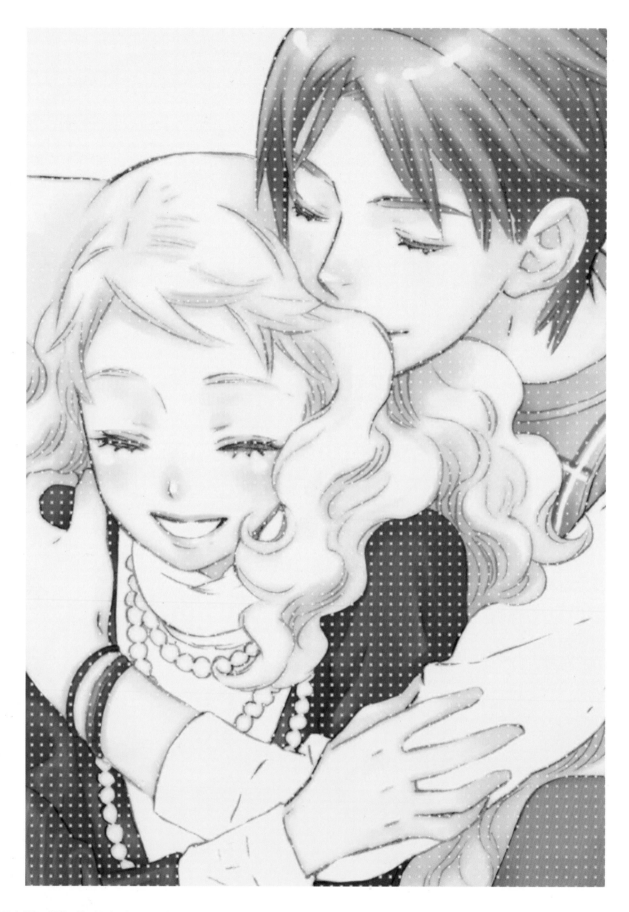

Page 40: *Aoi Hitomi (Blue Eyes)*, jacket illustration for drama CD with supplementary coterie magazine, Kikka, August 2004, © 2004 Lily Hoshino/sugarboy/MANDARAKE. "The story is about a mermaid, so I tried to color the background subtly with ocean blue, which is my favorite color." **Page 41:** *Aoi Hitomi (Blue Eyes)*, illustration for drama CD with supplementary coterie magazine, Kikka, August 2004, © 2004 Lily Hoshino/sugarboy/MANDARAKE. "I don't usually have the chance to do a close-up illustration, hence, I enjoyed painting this picture. I didn't consider the details, and just painted at one burst." **Page 42-43:** *Super Double*, color illustration, Rutile Vol. 7, 2004, © GENTOSHA COMICS INC. All rights reserved. "This front page illustration depicts a story about certain types of boy and girl androids. I created a simple composition to compare them." **Page 44:** *Neko Sato (Sugar Cats)*, cover illustration, October 2004 10, coterie magazine. "After painting the entire bodies of the characters, I enlarged the picture to project the chests. The layer with white dots created a good effect."
Page 45, top left: *Harem de Hitori (Alone in My King's Harem)*, cover illustration, BE x BOY Comics, June 2004, © 2004 Lily Hoshino/BIBLOS. "I removed the blue layer that covered the entire picture when it was used for a cover illustration, although the original one illustrated a nocturnal mood." **Page 45, top right:** *Yoru ni Umareta (Born at Night)*, title page illustration, MAGAZINE BE x BOY, December 2004 issue, © 2004 Lily Hoshino/BIBLOS. "I think I succeeded in capturing the character of the queen in this Illustration for a scene, "The Queen of the Night Alights…". **Page 45, bottom left:** *Harlem de Hitori (Alone in Harlem),* editorial illustration for BE x BOY Comics, June 2004. © 2004 Lily Hoshino/BIBLOS. "The subject of this illustration was nighttime on this side of the mirror, daytime on the other side of the mirror, but the artwork itself did not clearly show this message. I still feel a little regret whenever I look at it." **Page 45, bottom right:** Quarterly magazine *Comickers* spring 2004 issue, Alternative *Comickers-Moe-*Vol. 3, "Demi-human" illustration, © Bijutsu Shuppan-Sha. "I composed this picture with my favorite motifs: girl, sailor outfit, wings, and school. I really enjoyed painting with a euphoric mood throughout the entire work."

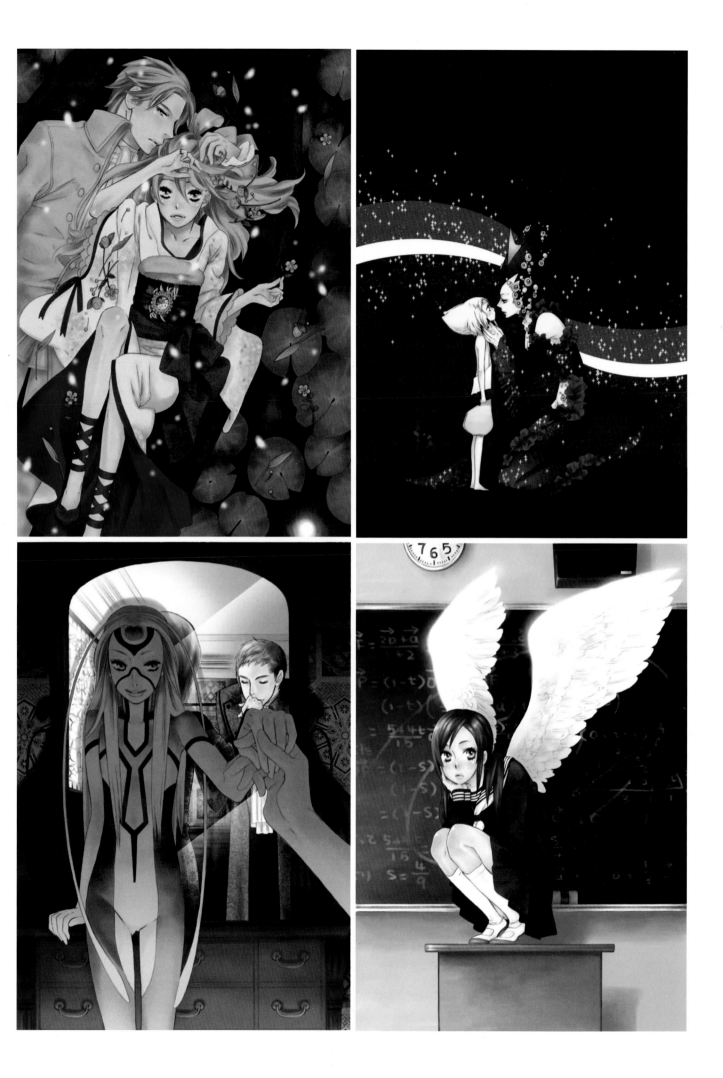

STEP-BY-STEP

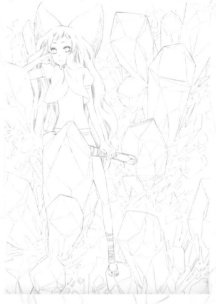

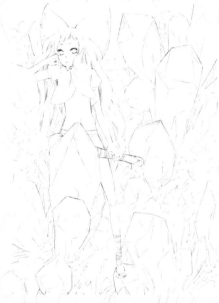

01 I used manga draft paper for the rough sketch, as it was easy to draw on.

02 I traced the rough pencil sketch also on manga draft paper, and scanned it.

03 After scanning it at 600 dpi grayscale, I adjusted the resolution to 350 dpi, then, drew the lines clearly using the "Brightness/Contrast" adjustment. I erased the dust and smudges with the Eraser tool.

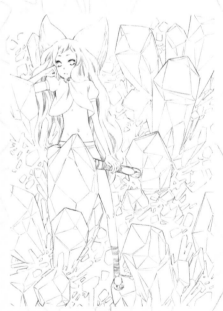

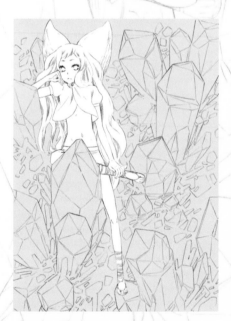

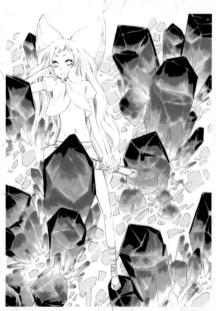

04 I loaded the selection for the main lines as they were retained in grayscale tone, and converted the color mode to CMYK. I expanded the selection by two pixels, and used the Blur filter by a radius of two pixels. After filling in the color, the main lines produced a bleeding image. I laid this on the background layer using Multiply mode.

05 I usually color the main and outstanding objects first, followed by the characters' skin in composing the color using the data. For this work, I started painting the jewels in the background.

06 I colored the jewels roughly, while deciding their color tone.

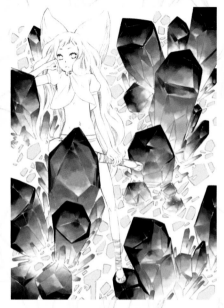

07 Next, I colored more finely on the rough drawing.

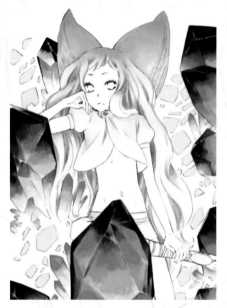

08 After painting the jewels, I applied the basic color roughly to the hair and the clothes.

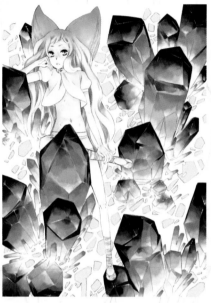

09 I loaded the section for the basic coloring, and shaded the hair and the clothes. I painted the skin without making the color appear dull against the entire picture.

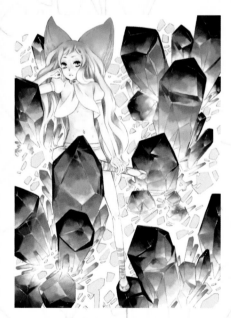

10 I adjusted the color of each part in the drawing, while checking the whole picture.

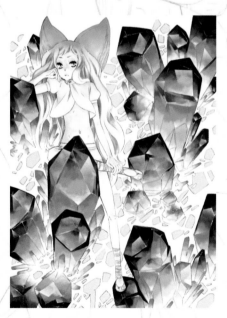

11 I highlighted the hair, eyes and jewels, and finally, completed the work.

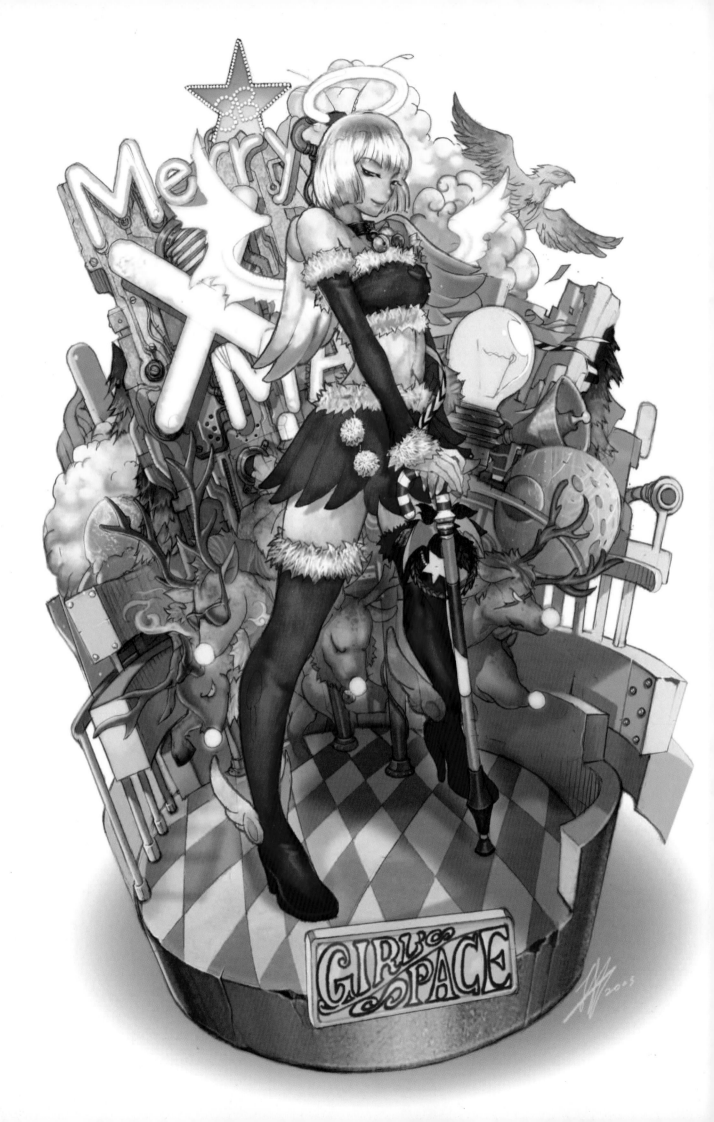

Jeong Juno

ジョン・ジュノ

An up-and-coming illustrator, Jeong Juno has focused on game-graphic design and illustration since he won the "New Face Award" in a manga magazine contest in Korea. He uses Photoshop skillfully, and his distinctive illustrations of fascinating, charming women reveal his formidable sketching skill. He also has a personal sense of color and a good command of layers that add a rich quality to his pictures.

Jeong Juno

Date of birth	: July 25, 1976
Gender	: Male
Place of birth	: Seoul, South Korea
Educational background	: University graduate
Web site	: http://studiosis.com/3rdBASS

Working tools

Digital

Main computer	: Windows
OS	: Windows XP
CPU	: Pentium4 3GHZ
Applications	: Photoshop 7.0, Painter 6
Memory	: 2G
HDD	: 160G

Hand Drawing and Painting

Paper	: Art paper

Favorite artists

Kazumi Yamashita, Renji Murata, Kim Hyung-Tae, Akihiko Yoshida, Alphonse Mucha

Published works

Ez2DJ, Dancer, NC software; animation movie; interface design
LINEAGE II, NC software; character design and original imagery
LINEAGE II, Visual Fun Book, Mediaworks Inc., 2004

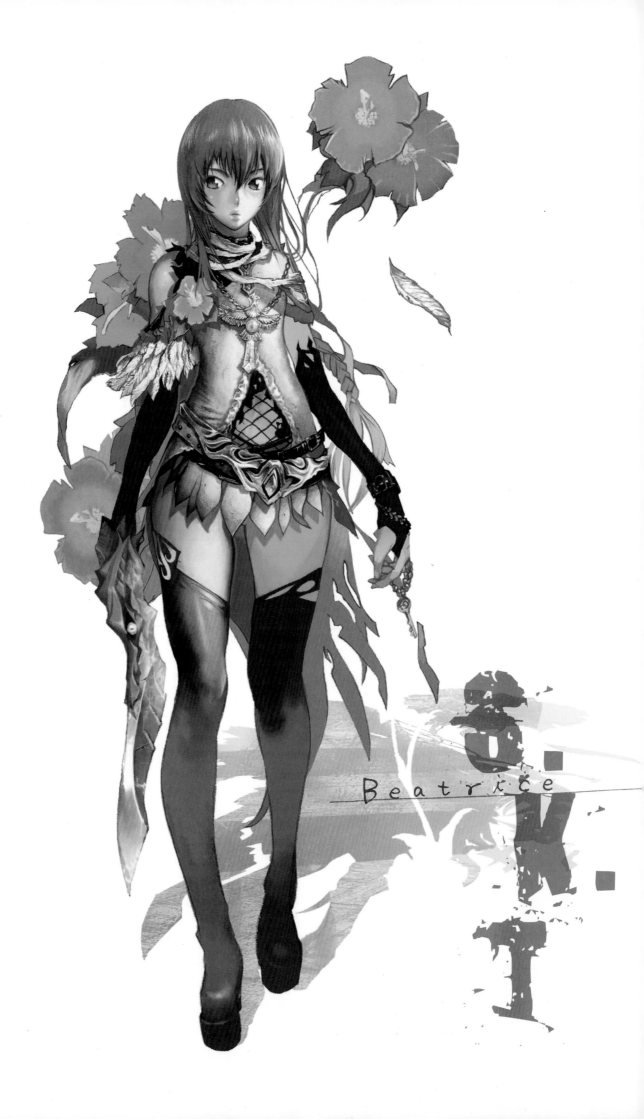

Beatrice

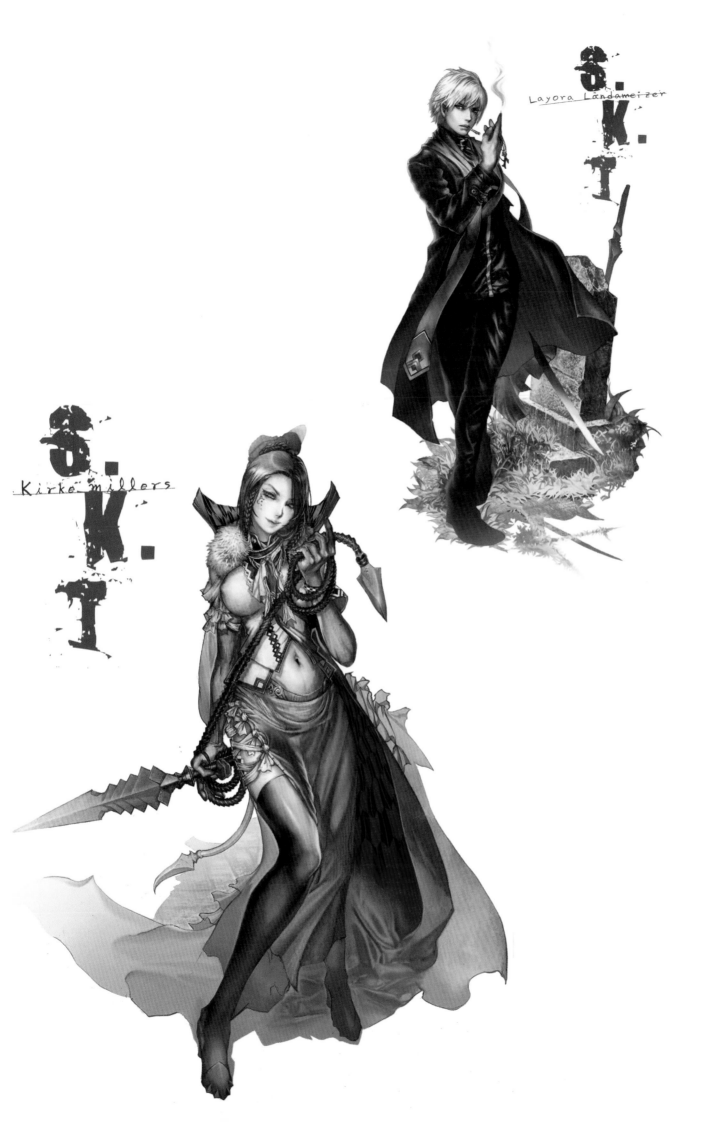

S. K. I
Layora Landameizer

S. K. I
Kirke millers

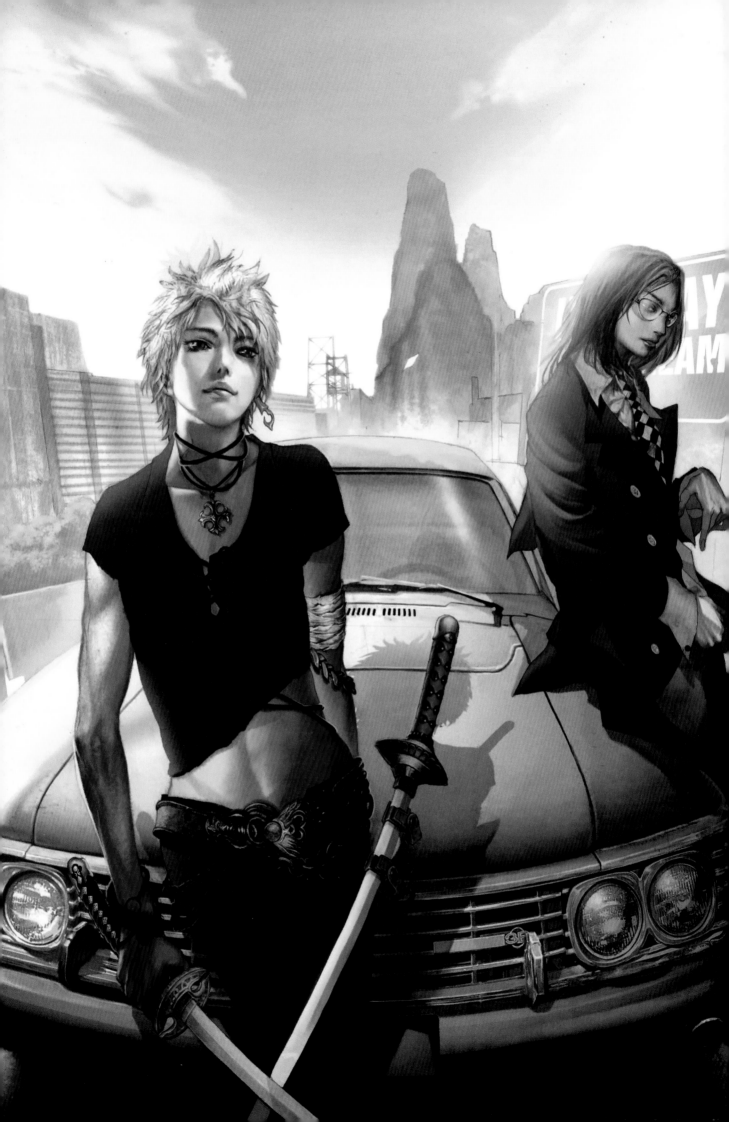

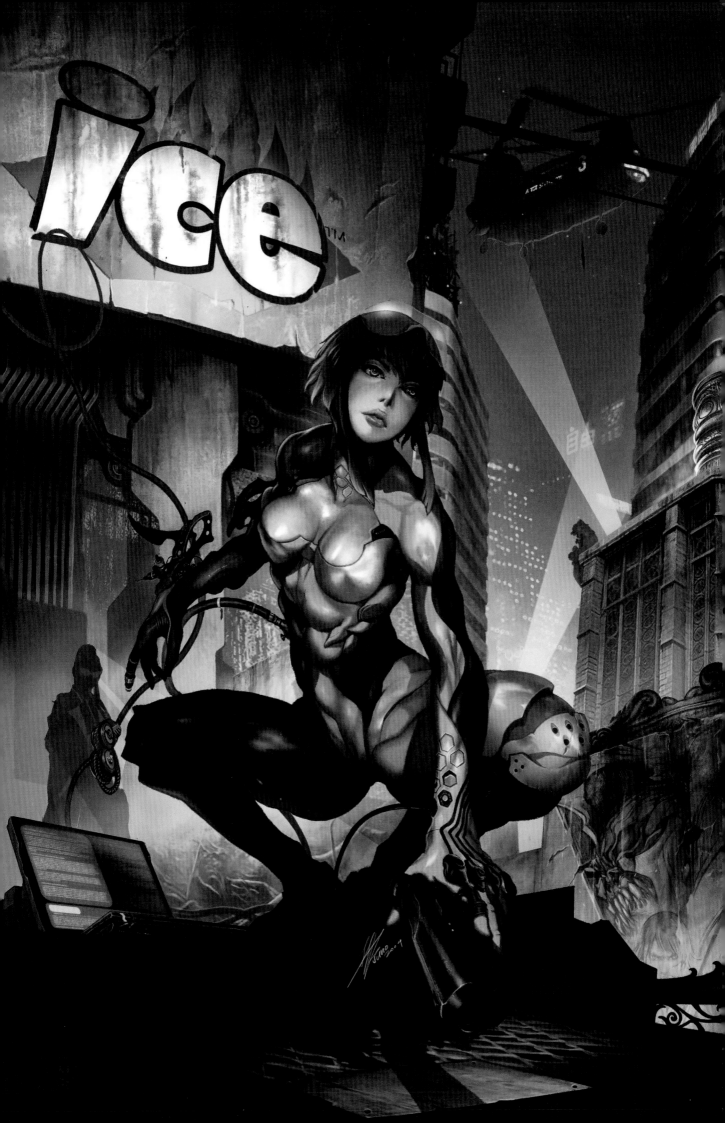

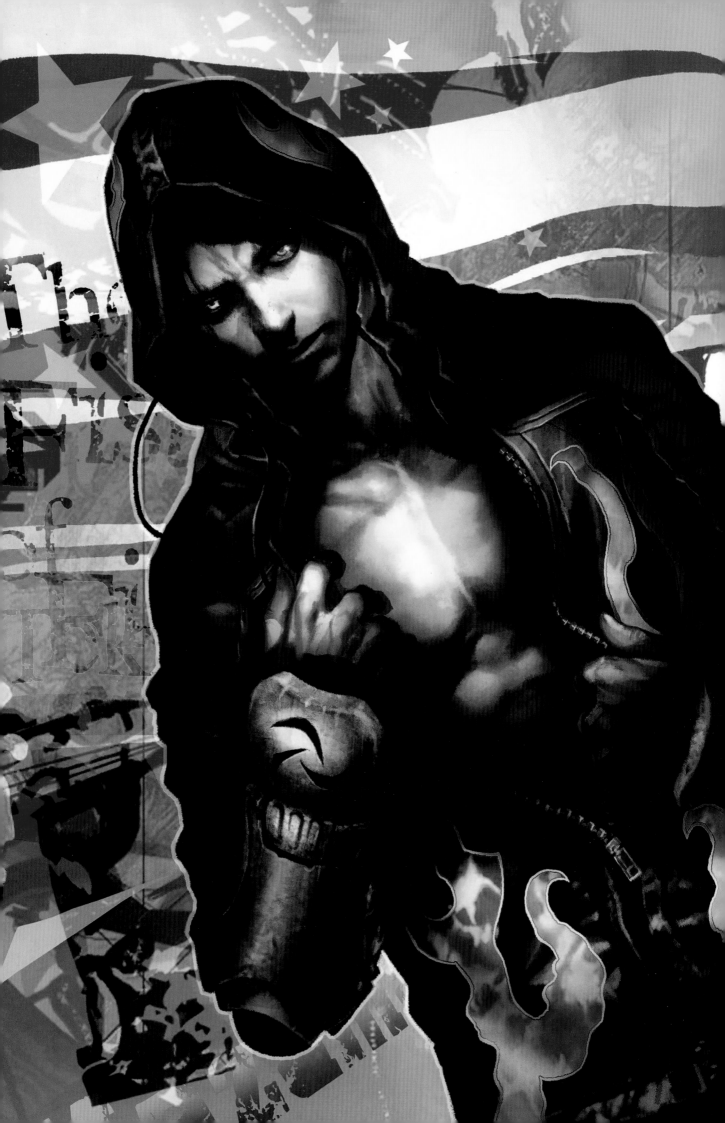

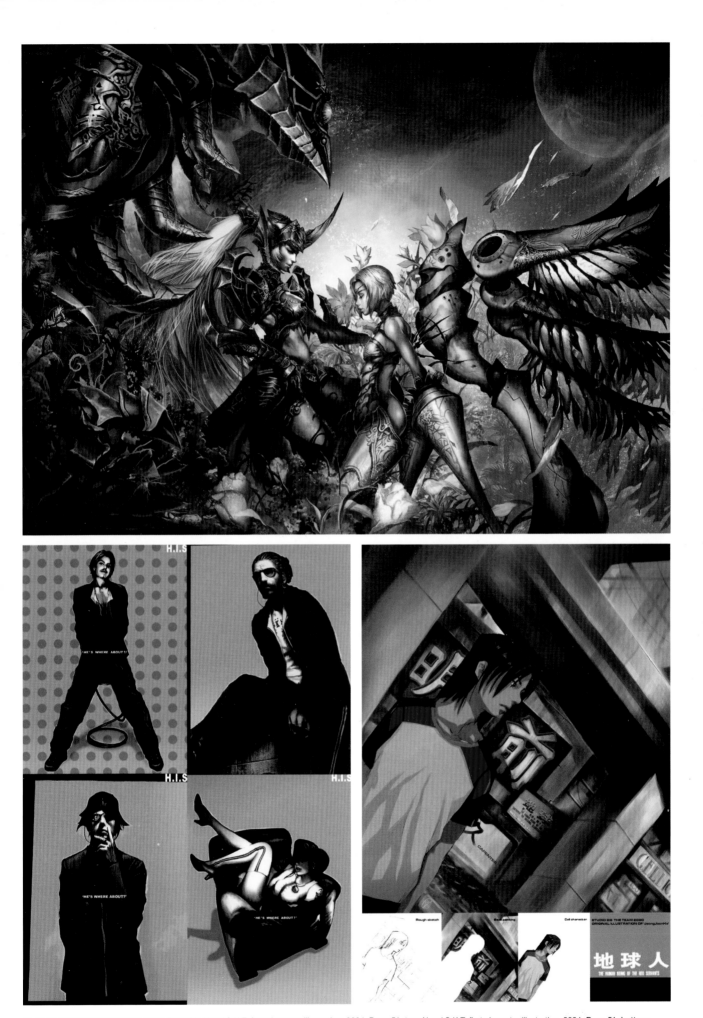

STEP-BY-STEP

01 First, I drew a rough sketch, and arranged the lines to prepare the basic picture.

02 I scanned the hand-drawn picture, and captured the linear drawing in the computer.

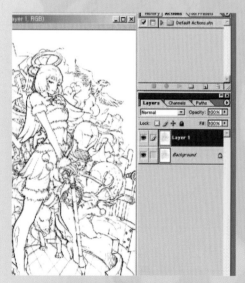

03 This image shows the method for capturing just the linear drawing, while making the white part transparent, using layer channels simply and quickly.

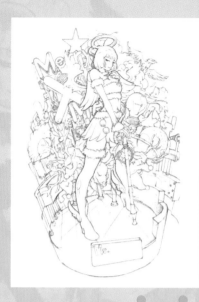

04 This image illustrates the formula method for using the Alpha channel, which I applied to the entire picture.

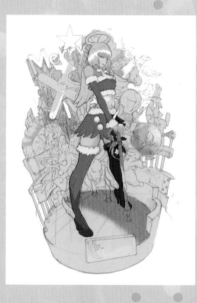

05 I applied the basic color roughly by using a large airbrush tool, which also expressed texture.

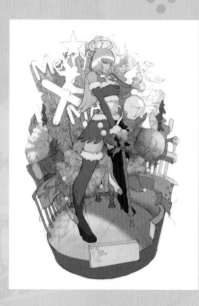

06 I painted the basic color section by section to decide the color direction of the final work.

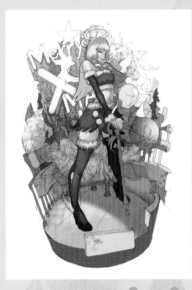

07 I added more color on the parts that I painted in step 06 to make them appear rich. Then, I drew more details, such as the girl's hair, clothes' shadows, and props, all at the same time.

10 I created some effects for specific parts by using overlay and other tools.

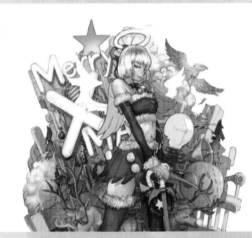

08 I colored the background and text in further detail by dividing the layers.

11 This image illustrates a detail of the complete picture, where color was applied.

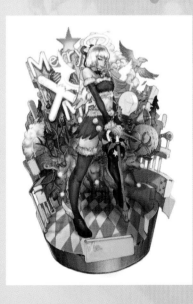

09 I adjusted the entire tone by using an overlay channel.

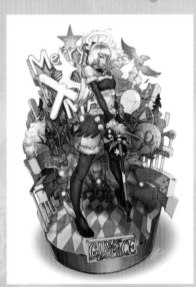

12 In the final adjustment stage, I completed the picture by controlling the entire balance and color.

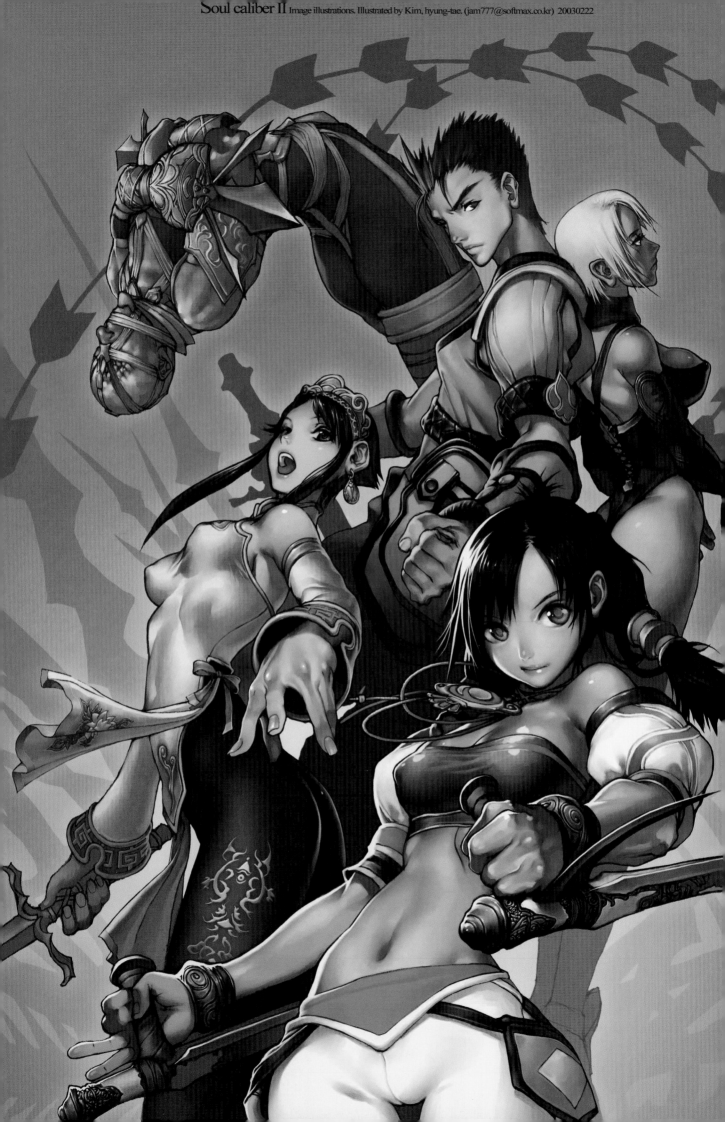

Kim Hyung-Tae

キム・ヒョンテ

Kim Hyung-Tae is an influential, Korean illustrator, well known for his popular game-character designs. His characters, such as lovely girls, assume unique postures that have become famous in Japan. He composes pictures using light and dark effects and embellishes them to resemble oil paintings—a technique that represents his dignified world.

Kim Hyung-Tae

Date of birth	: February 7, 1978
Gender	: Male
Place of birth	: Seoul, South Korea
Educational background	: Chung Aug University, Visual Communication Design course, temporary withdrawal

Working tools

Digital

Main computer	: Windows
OS	: Windows XP
CPU	: Pentium4 2.4GHZ
Applications	: Photoshop 7.0, Painter 6.1
Memory	: 1G
HDD	: 320G (160G x 2)

Hand Drawing and Painting

Paper	: B4 copier paper
Coloring	: 0.5mm mechanical pencil, Tombow MONO eraser

Favorite artists

Renji Murata, Akihiko Yoshida, Jeong Juno

Published works

THE WAR OF GENESIS 3, *THE WAR OF GENESIS 3 Part 2*, Softmax Co. Ltd., 1999-2000: character design
MAGNA CARTA, Softmax Co. Ltd., 2001: character design and realtime 3D polygon overall character creation
Oxide2x, Enterbrain, Inc., 2005: image collection

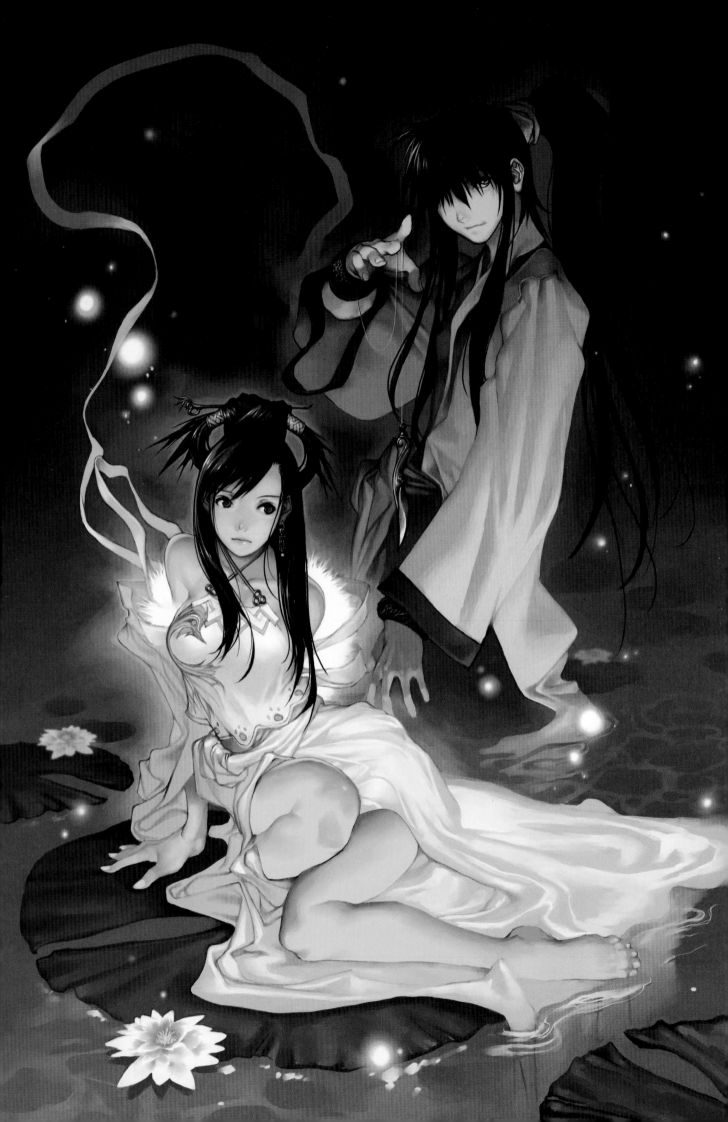

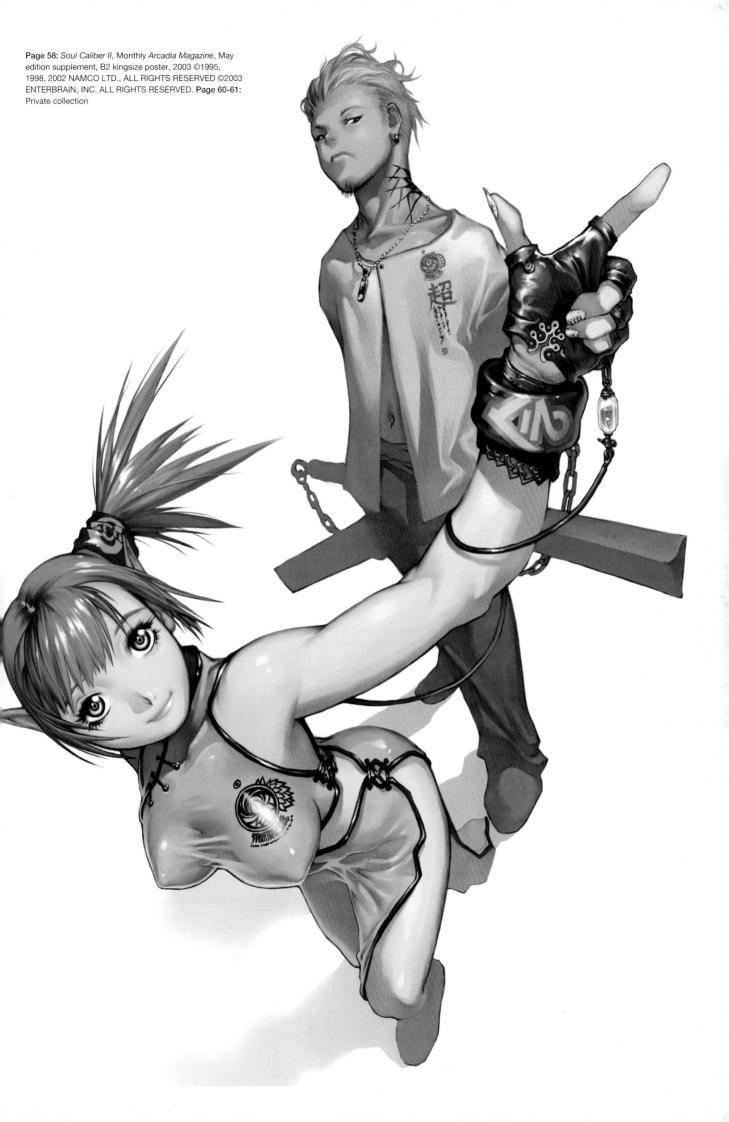

STEP-BY-STEP

01 I sketched on B4 paper using a mechanical pencil, and positioned the characters based on my method of looking up at the objects from a low angle. I emphasized the twisted body to express a dynamic image. I scanned the sketch, arranged the lines, adjusted the color level, and separated the line layers with Photoshop. Next, I loaded the image in Painter.

02 First, I applied a monochrome tone to the entire picture. I shaded roughly, following the perspective of the characters and the background.

03 I started coloring each part of the frame after creating the color tone. Many game creators use this popular method to avoid producing any excessive data.

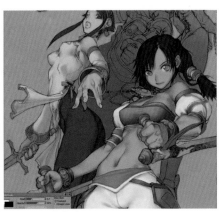

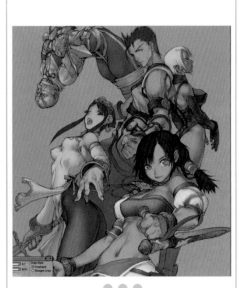

04 I proceeded to color the skin, hair, clothes, and the main character's props.

05 I painted the same elements in the previous steps for the characters in the background.

06 I colored all the characters roughly, and used them as the foundation for the picture. I was careful not to upset the entire harmony in expressing each character's personality.

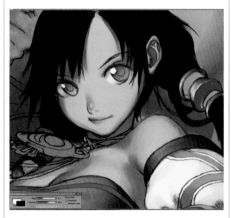

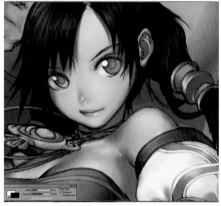

07 I applied some shades and a lighter color on the bulges of the skin. This method of representing undulation and sheen on the skin is also used in oil painting.

08 I highlighted the hair, nose and eyes. It was rather difficult to illustrate an attractive Southeast Asian girl's dark skin, so I paid careful attention to the details. When the highlights were complete, I added more sheen and a gorgeous quality to the facial expression.

09 Next, I painted the background while considering the entire picture balance.

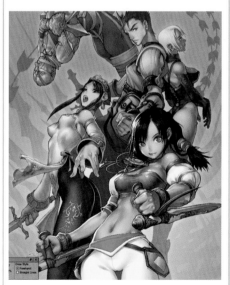

10 I colored the details, and presented the different textures of the leather piping, metallic accessories, and silk embroideries by combining light and shade reflections.

11 The main process was finished at this stage. I elaborated hips on the top right with smooth and beautiful curves, like a piece of pottery.

12 I adjusted the color of the characters and the background, and finally completed the work.

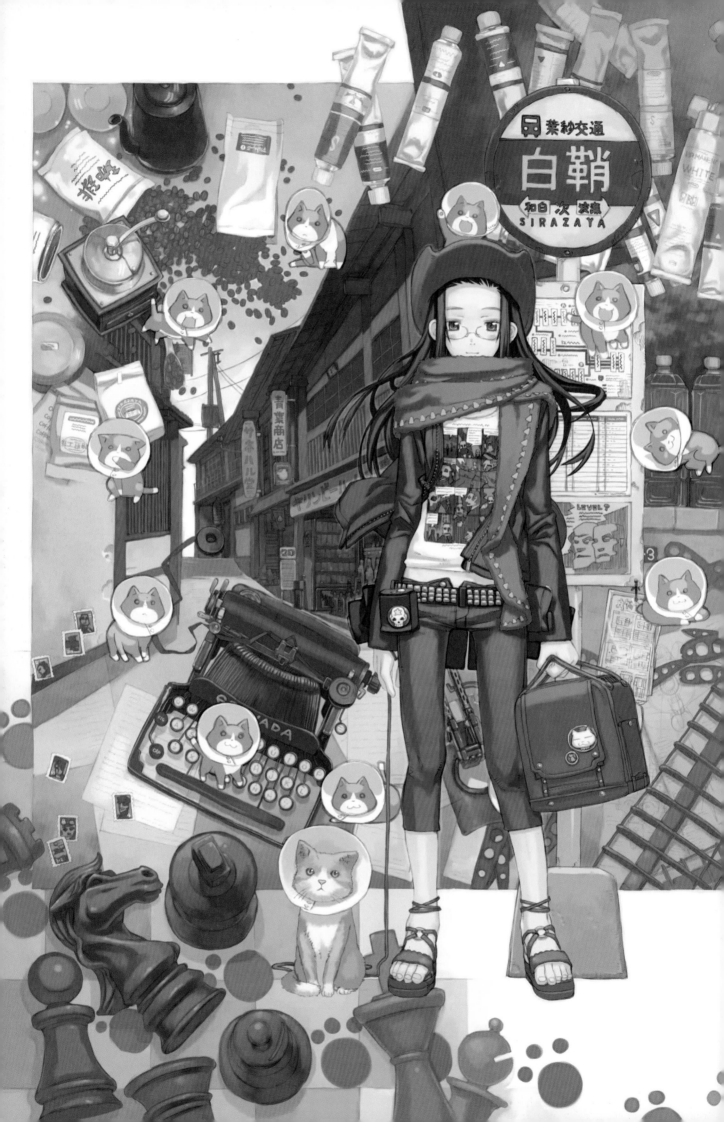

Kuroboshi Kouhaku

黒星紅白

Kuroboshi Kouhaku's world of images is immensely appealing. Each picture is founded on a strong drawing sense, with a well-balanced composition, and soothing yet saturated colors. He is remarkably gifted in using layers to adjust colors. He never skimps on his painting even for the props in the background, which could be simplified; yet the painting does not look cluttered. His illustrations are full of wonderful details and are endlessly entertaining.

Takeshi Iiduka Kuroboshi Kouhaku

Date of birth	: November 19, 1974
Gender	: Male
Place of birth	: Japan
Educational background	: High school graduate
Web site	: http://ww2.tiki.ne.jp/~kuroboshi/

Working tools

Digital

Main computer	:DOS/V
OS	:Windows Me
CPU	:Pentium4 1G
Applications	:Photoshop4.0J
Memory	:512MB
Hand Drawing and Painting	:0.3mm mechanical pencil

Favorite artists

Osamu Tezuka, Norman Rockwell

Published works

Kino's Journey, by Keiichi Shigusawa, Mediaworks Inc.: cover design and illustration (as Kuroboshi Kouhaku)
SUMMON NIGHT, Banpresto Co., Ltd.: game character design for PS and PS2 (as Takeshi Iiduka)

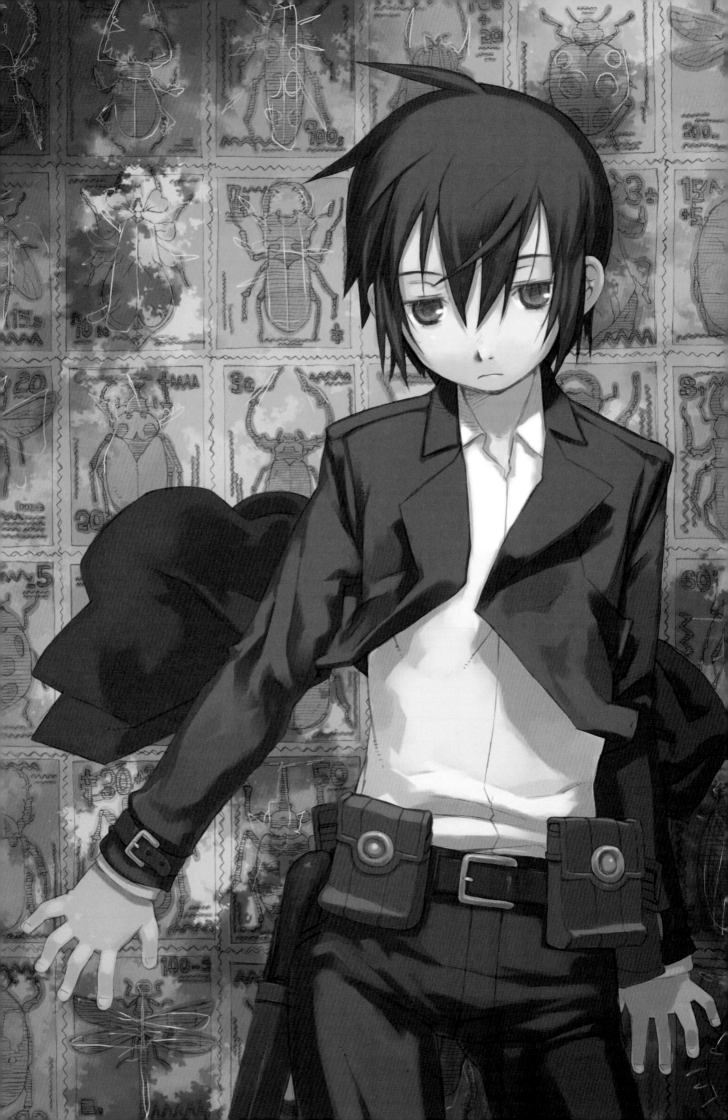

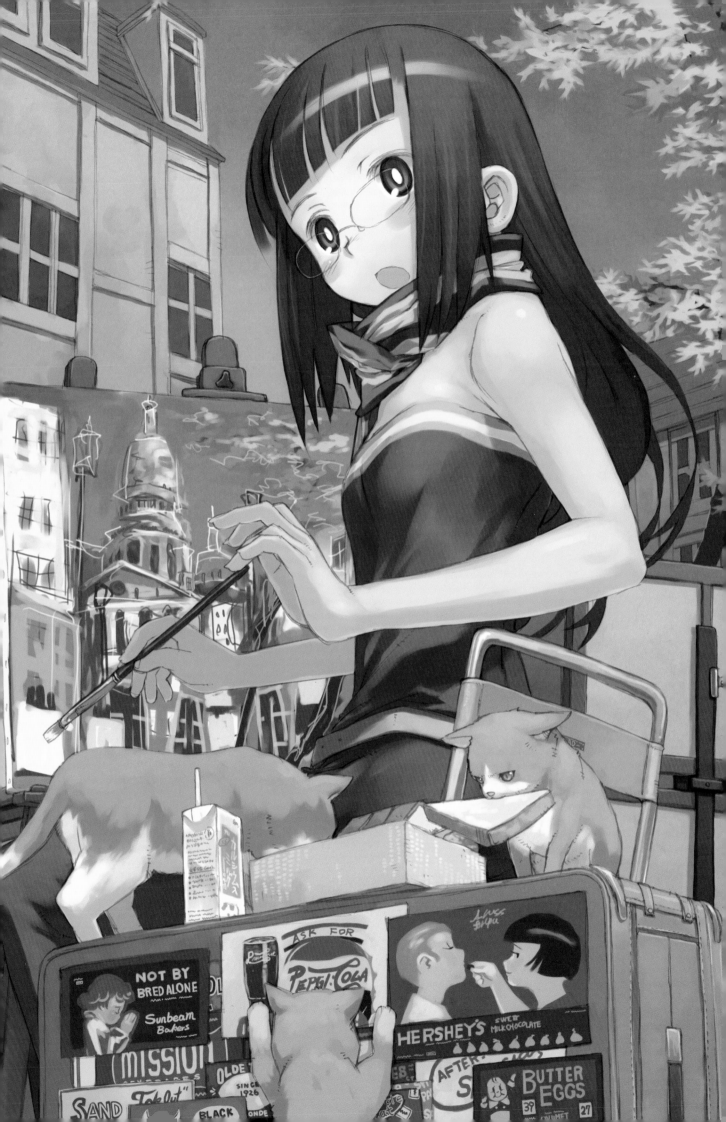

Page 64: Step-by-step adaptation, Quarterly magazine *Comickers* Summer 2003 issue, cover illustration, © Bijutu shuppansha Page 66: *Kino 8, Kino's Journey-The Beautiful World*, cover illustration, Dengeki Bunko collection, October 2004, written by Keiichi Shigusawa/Mediaworks Inc. © KEIICHI SIGSAWA/Mediaworks Inc. "Personally I don't like insects, but I painted them because I like their shapes and patterns, and I thought that they resemble Kino's theme." Page 67: Quarterly magazine *Comickers* autumn 2003 issue, *Alternative Comickers-Moe-Vol. 1* "Glasses" illustration, © Bijutsu shuppansha. Page 68-69: *Kino's Journey*, announcement poster for "2004 Dengeki Bunko Collection 1000 Title Fair," August 2004, © KEIICHI SHIGSAWA/Mediaworks Inc. "Since it was a poster for the train station wall, I painted it in detail so that people who don't know my work would think, 'What is it?'" Page 70: *Summon Night 3 Main Illustration*, PS2 game "Summon Night 3" poster illustration, June 2003, © FLIGHT-PLAN © BANPRESTO. "The use of numerous characters gives the picture weight and a cheerful atmosphere, perfect for a sales promotion illustration. Viewers can imagine the story with fun and anticipation." Page 71: *Summon Night 3 Package Illustration*, PS2 game "Summon Night 3" package illustration, September 2003, © FLIGHT-PLAN © BANPRESTO. "The characters are simply arranged to give a pleasant impression for a package design."

STEP-BY-STEP

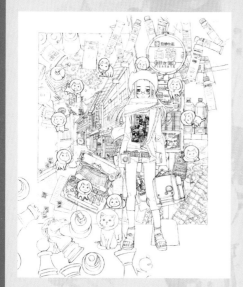

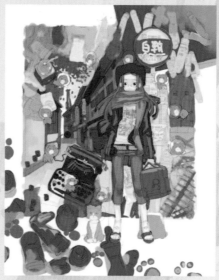

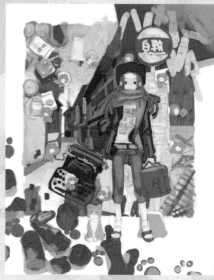

01 I drew a rough sketch considering the balance of specifications. I was conscious of the flow of the entire image, so I composed it by applying contrast between the inconspicuous, simple parts and the conspicuous high-density parts. This picture is relatively small, so it was easy to maintain a good balance among the elements.

02 This is quite a detailed linear drawing. I used main lines for the final work, so I thickened the lines at the front and narrowed the ones in the background. I drew the original picture on the back of a dummy sheet. I used photographic collections and my own photographs for the image of the cats. I also randomly arranged old color tubes that I had used before. I used other materials from magazines about antiques, and downloaded some from the Internet.

03 I colored the image roughly considering color composition, while leaving the pen on the drawing tablet. The outcome was a colorful composition, although it expressed a calm image because I used low-saturated colors for the entire picture.

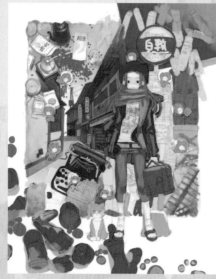

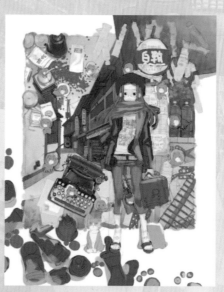

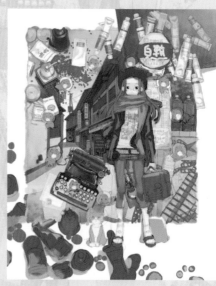

04 I tried to keep the color saturation level as low as possible, selecting the most visibly effective tone. I painted the whole picture with the airbrush tool, set at a blur point of 100%, and a painting interval of 1%. The other settings remained the same when I installed the software.

05 I painted the objects in order, from upper left to bottom right: coffee, town, typewriter, paint tubes, chess pieces and stamps, bus stop and drawing, girl and small letters, cats.

06 Although I can basically complete the picture using just one layer, I used separate layers for painting the text and adding the detailed effects. First, I finished painting the objects behind the image vigorously, then later the ones at the back, and finally those in the foreground.

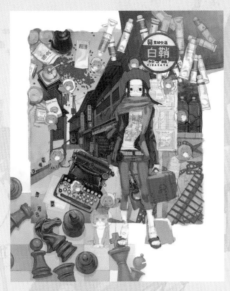

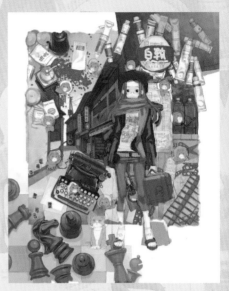

07 To check the picture's hue, I filled and saturated the image with a cream color using "Multiply mode/Tolerance 100%." I do not usually do this step.

08 I applied picture simulation because I thought the image might appear unbalanced. The image on the left shows the stage before I added a layer, and the one on the right shows the stage after I added it. At this stage, I also checked any slight color differences. Finally, I added this layer using "Multiply mode/Tolerance 1%."

09 I colored more details. I painted the girl in the foreground, and finally the cats in detail.

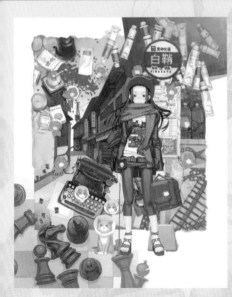

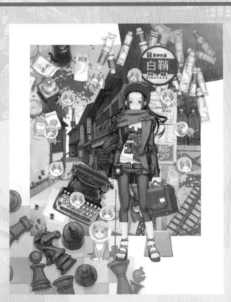

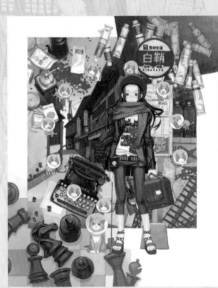

10 I laid another layer for the fine details, such as the text and other highlights.

11 I thought the overall color was pale, so I darkened it. I copied the main layer used for coloring and pasted it on the drawing using "Multiply mode/ Tolerance 18%." The adjustment was fine, and it added richness to the picture. Since I am not good at arranging the tone curves, I sometimes employ a method of laying the copied layer on the picture, and adjusting its tolerance. Then, I coordinate the color for the entire picture.

12 I weakened the lines in the background, and reddened the girl's cheeks. I painted more details, trying to achieve a well-composed hue and color balance. Finally, I completed the picture.

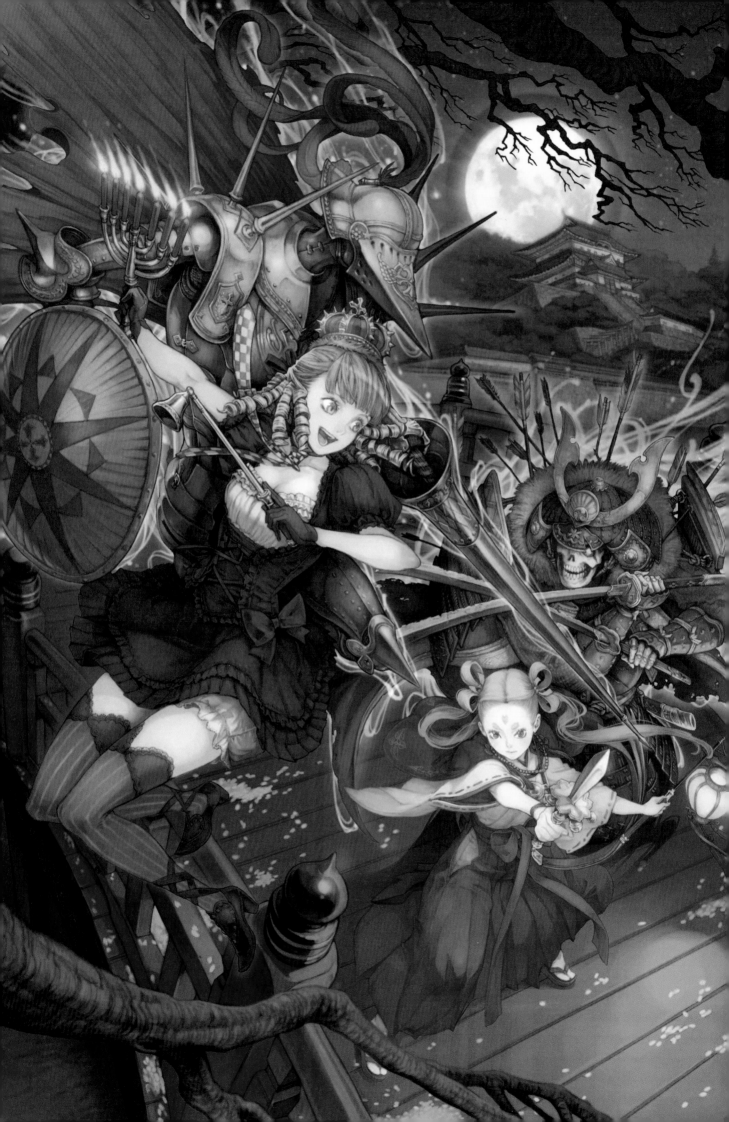

HACCAN

HACCAN

Haccan creates attractive characters that range from fantasy to modern. He works on the computer, using the Painter's Watercolor Brush tool for painting the sketch plan, and Photoshop for special effects and texture.
Haccan paints entirely with the computer, yet each work conveys a magnificent feeling as if he has created a watercolor painting by hand.

HACCAN

Date of birth	: April 6, 1978
Gender	: Male
Place of birth	: Hokkaido, Japan
Educational background	: Hokkai Gakuen University, Department of Economics, Economics
Web site	: http://www1.odn.ne.jp/haccan/

Working tools

Digital

Main computer	: Windows
OS	: Windows XP
CPU	: 1.66GHZ
Applications	: Photoshop 5.5, Painter 6
Memory	: 480MB RAM
HDD	: 75GB

Favorite artists

Svend Otto S

Published works

BLOODLINK series, by Takashi Yamashita, Enterbrain, Inc.; cover design
Duel Masters, Wizards of Coast Inc., Shogakukan Inc., Takara Co., Ltd., Mitsui-Kids, card illustration
The Belgardiad series, by David Eddings, Hayakawa Publishing Co.; cover design

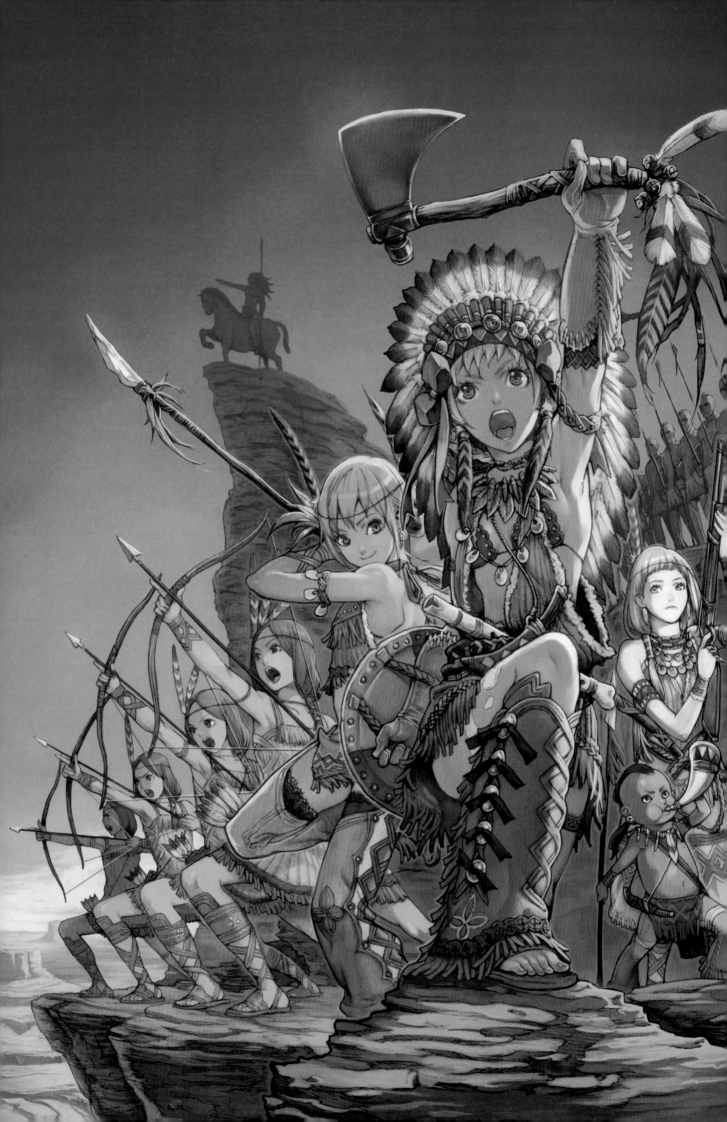

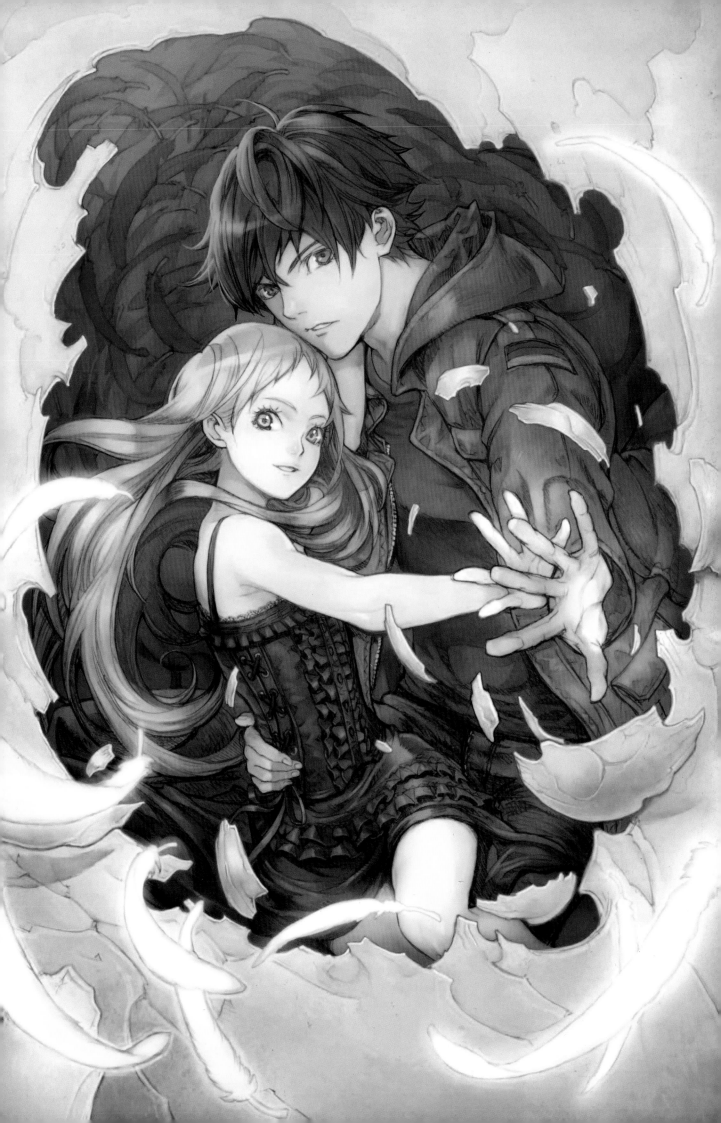

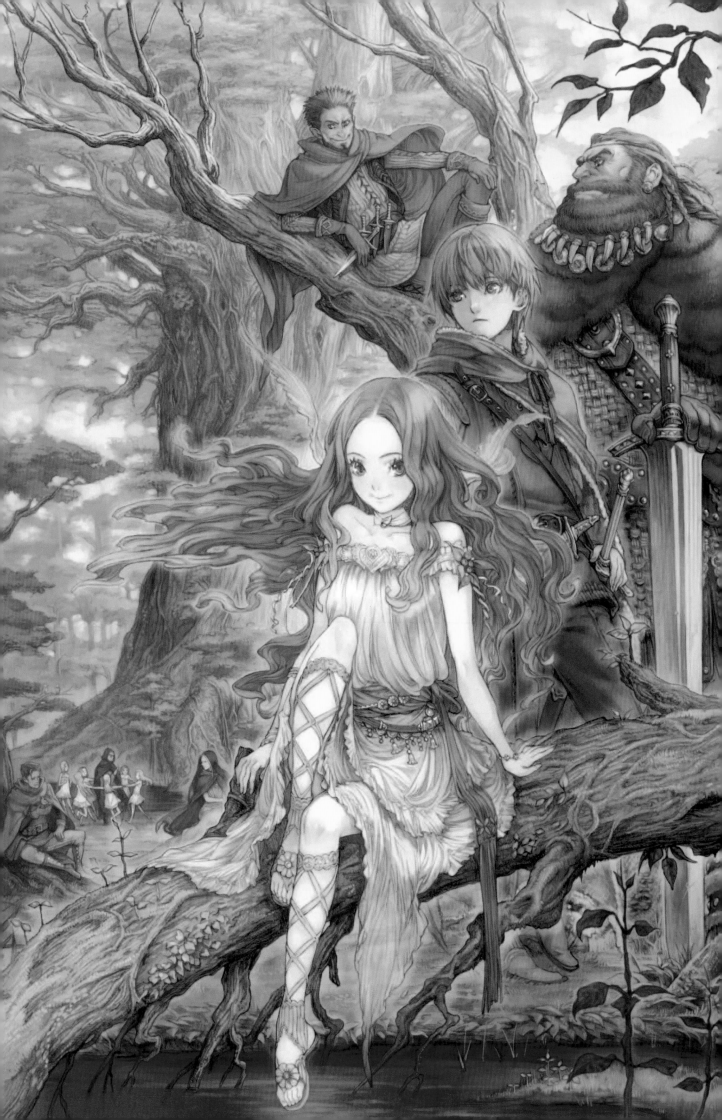

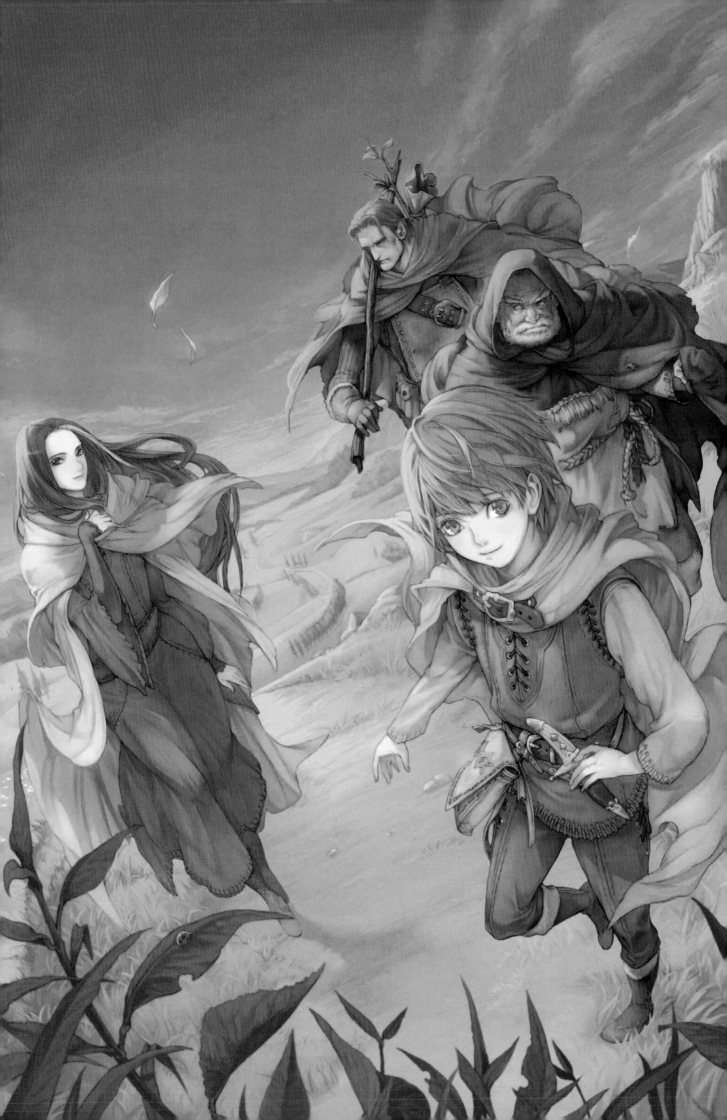

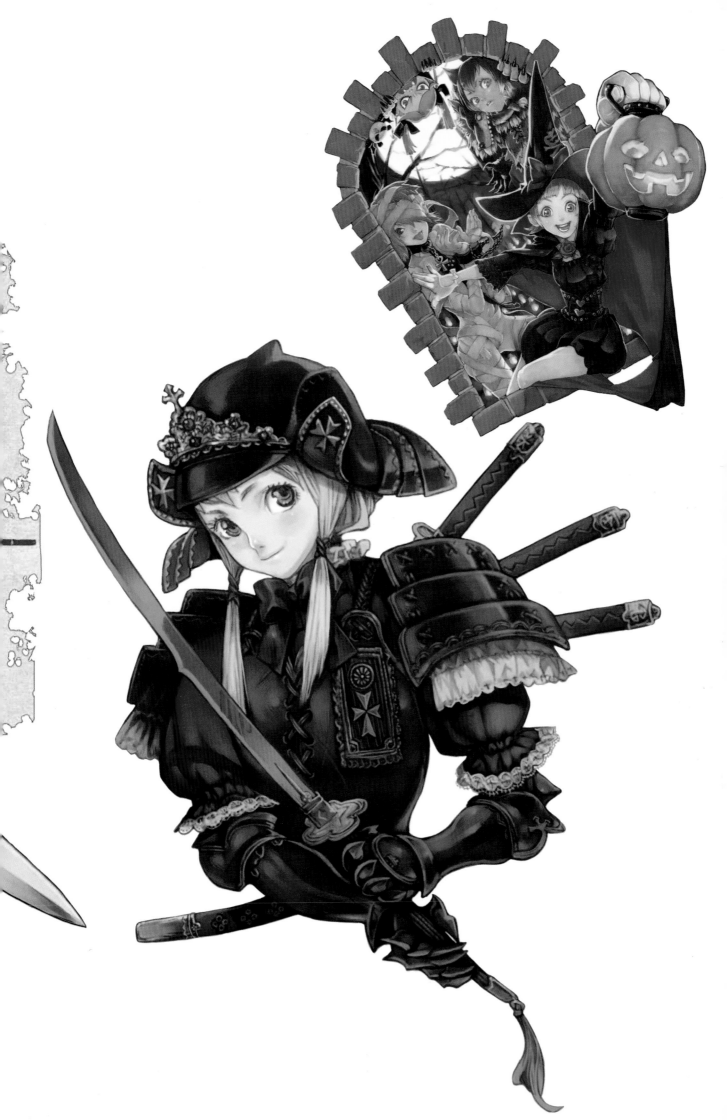

STEP-BY-STEP

01 This picture displays a duel between a Japanese samurai and a western warrior. I created the characters by imagining a battle that would show the winner commanding her shadow guardians, who were born from candlelight, to extinguish her opponent's candle flame.

02 I drew a rough sketch with the computer using the characters I designed, and printed it out. Then, I traced it on paper using a mechanical pencil, and divided the characters and the background. I scanned them and overlaid the captured images as separate layers.

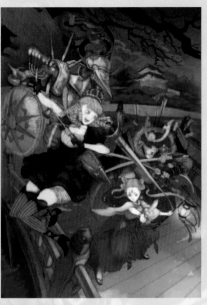

03 I colored the image roughly to simulate the final work.

04 To capture the night setting, I applied dark blue as the basic color for the entire picture using Painter 6.0's Watercolor Brush Tool.

05 I painted over the background part by part on the dark blue base without drying it. I enjoyed the way the unpredictable and miraculous color emerges when I blended colors with the dark blue base. Afterwards, I overwrote the data, and saved it as a new file for later use.

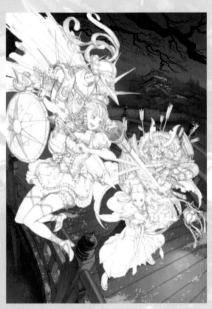

06 I dried the watercolor layer, merged it with a drawing layer, and made a clean copy of the details using the Chalk Brush Tool.

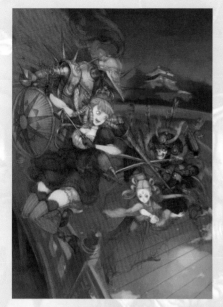

07 I opened the file that was saved in step 05, and applied color on the characters over the watercolor background using the watercolor brush. At this point, I painted the characters and the background in separate files.

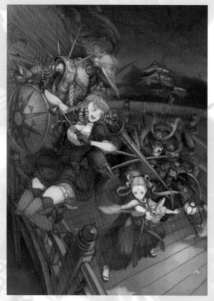

08 I dried the watercolor layer again, merged it with another drawing layer, and drew the character details using the chalk brush tool.

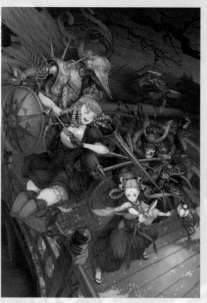

09 I combined the character layer and the background layer as one file. They still appeared bare and rough, so I was not yet satisfied with the image.

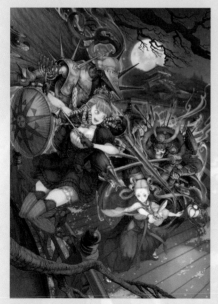

10 I transferred the data file to Photoshop 5.5, and increased the entire volume of the picture by adding effects. I adjusted the color to produce a good visual impression.

11 This image shows the final picture.

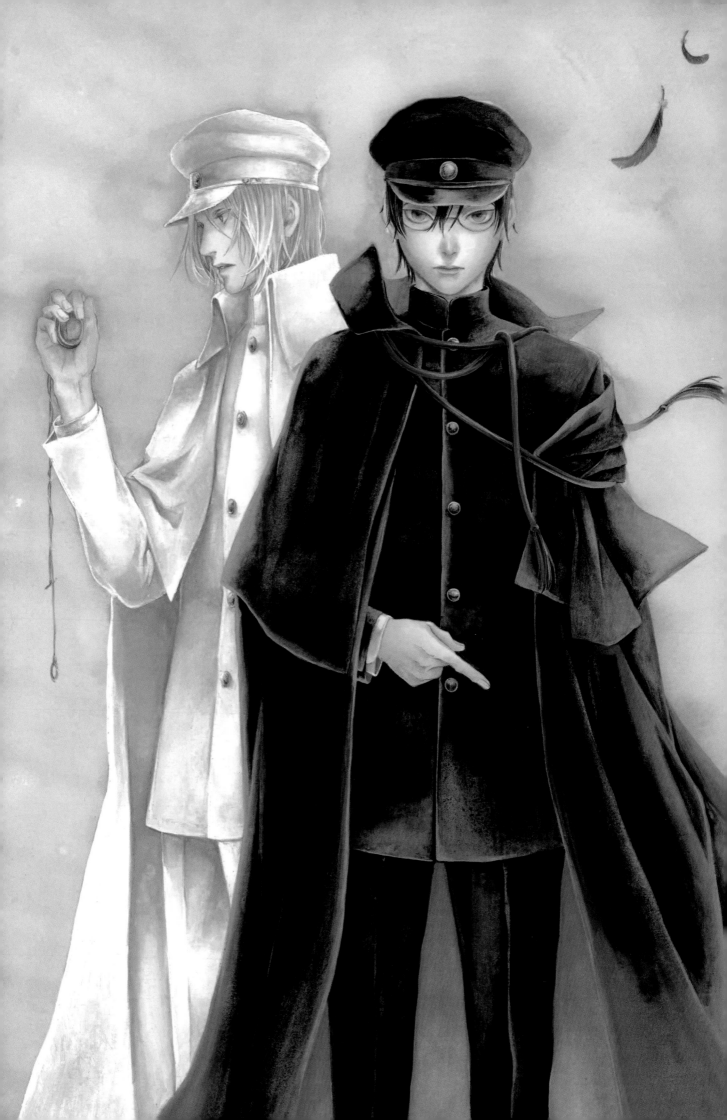

Kaoru Yukifuna

雪舟薫

Kaoru Yukifuna is known for her beautiful cover illustrations. Her use of subtle colors and faded hues creates a soft, feminine feeling. The artist's two-shot composition that features a charming muscular man and a slim, pretty boy is distinctively typical of her presentation style. All of her breathtaking illustrations are hand-painted, and capture the hearts of Japanese girls.

Kaoru Yukifuna

Date of birth	: March 13
Gender	: Female
Place of birth	: Gunma, Japan
Educational background	: High school graduate

Working tools

Hand Drawing and Painting

Paper	: BB Kent/rough, Arches watercolor paper/smooth
Coloring	: W&N transparent watercolor, HOLBEIN transparent watercolor, Dr. Ph Martin's, acrylic color
Brush	: Namura Azumabeni, Namura flat brush
Pencil for draft	: 0.3mm/B mechanical pencil
Pen holder & Metal Nib	: Zebra Maru-pen & Zebra pen holder, Zebra G-pen & Tachikawa pen holder T-25
Monochrome ink for main lines	: Japanese calligraphic ink, *Kaimei Bokujyu*, PILOT Drawing ink

Favorite artists

Mamoru Nagano

Published works

Kazanin Nikki Tsurezure, Craft/Taiyotosho
FLESH & BLOOD, by Natsuki Matsuoka, Tokuma Shoten Publishing Co. Ltd.
Kanraku no Miyako (City of revelry—Cockaigne) series, by Yu Komazaki, Kadokawa Shoten Publishing Co. Ltd.
Uskabard no Matsuei (Descendant of Uskabard) series, by Riuto Takeuchi, Kodansha Ltd.

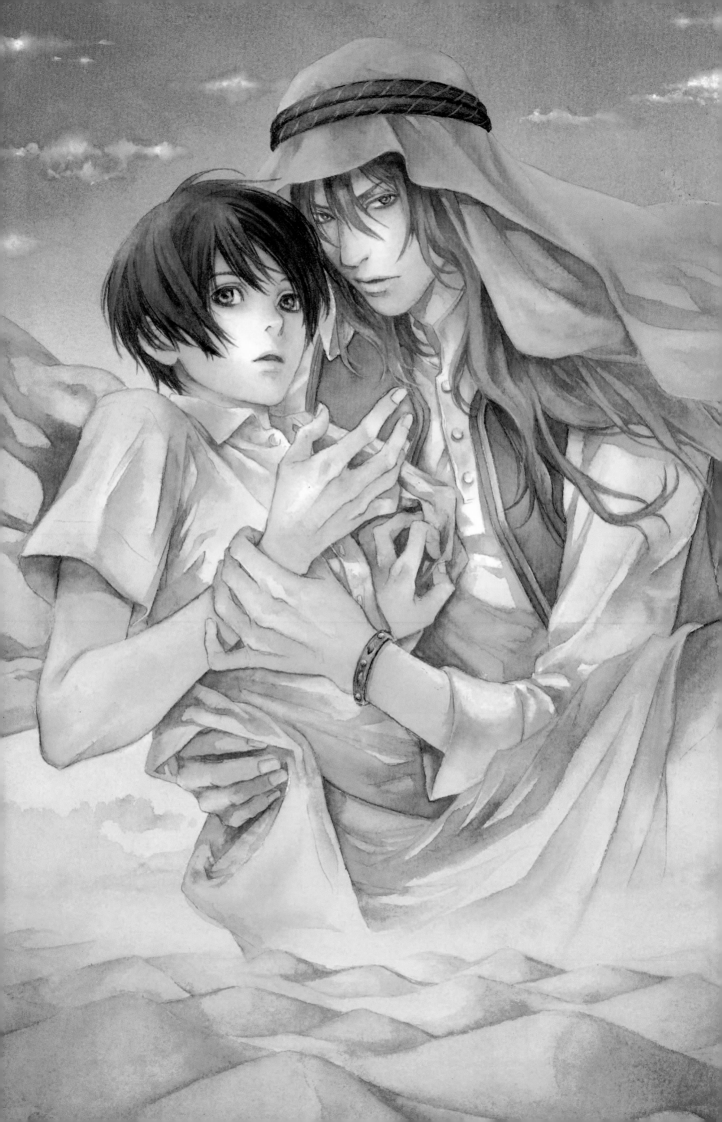

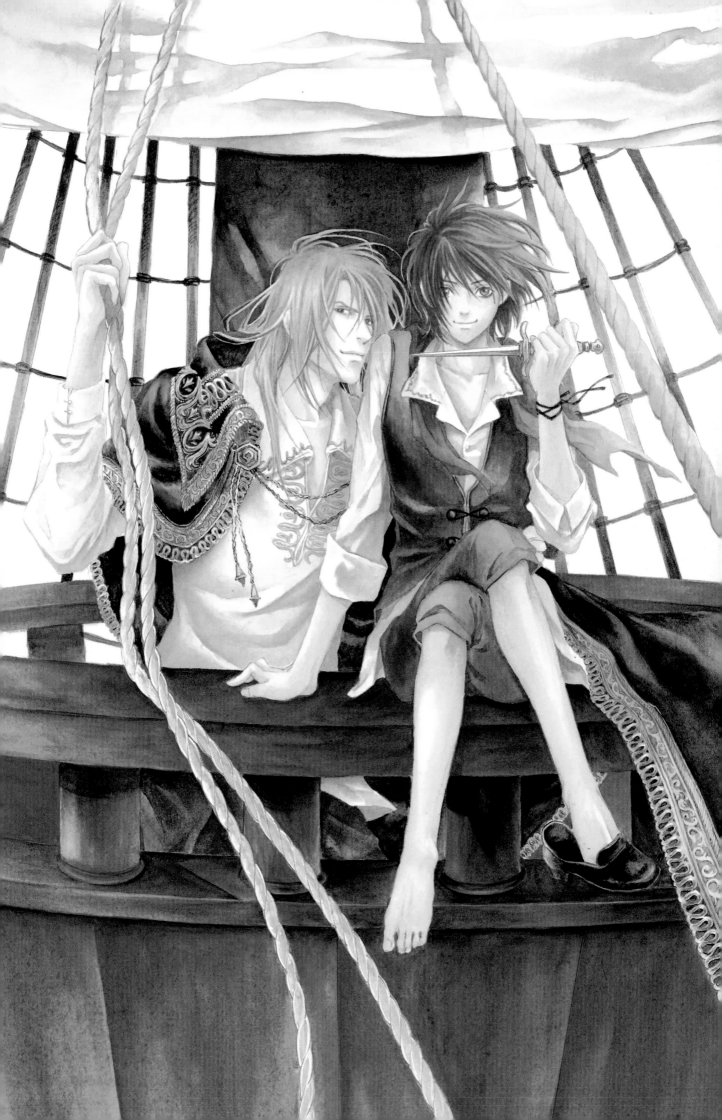

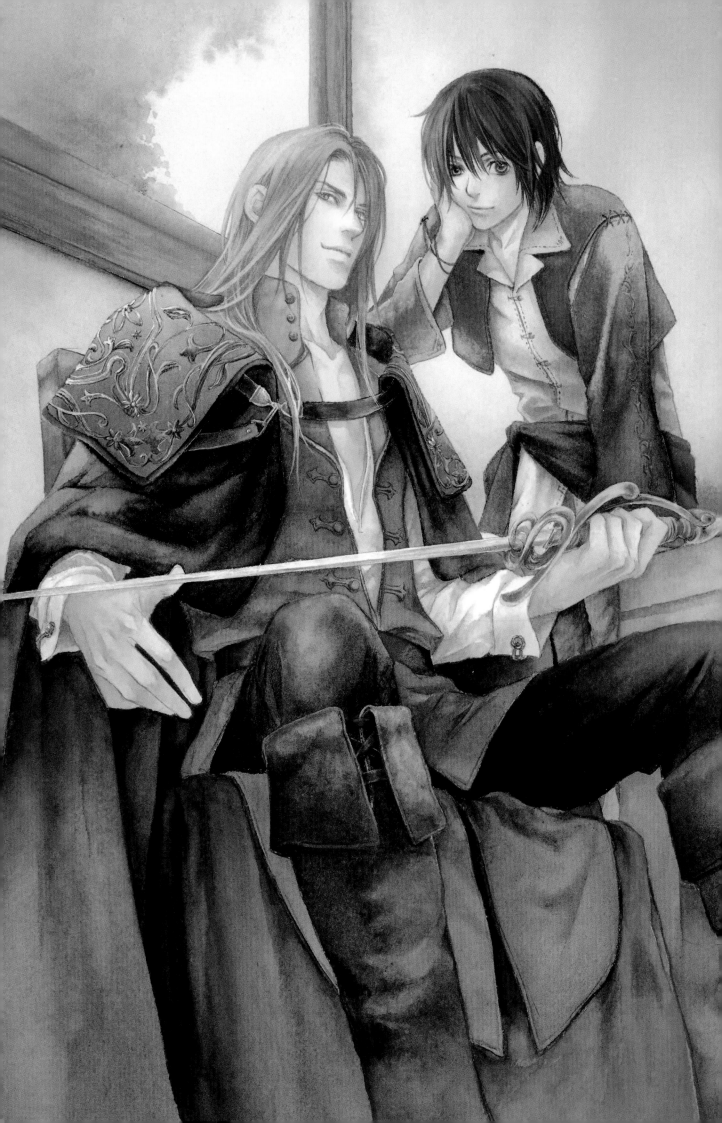

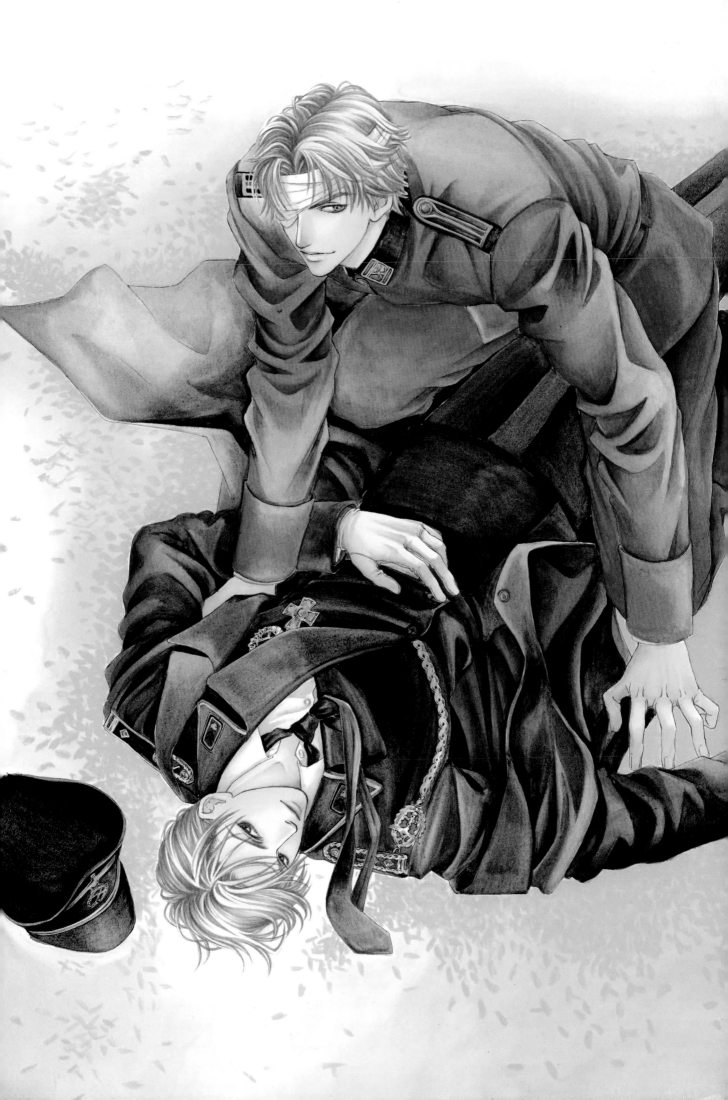

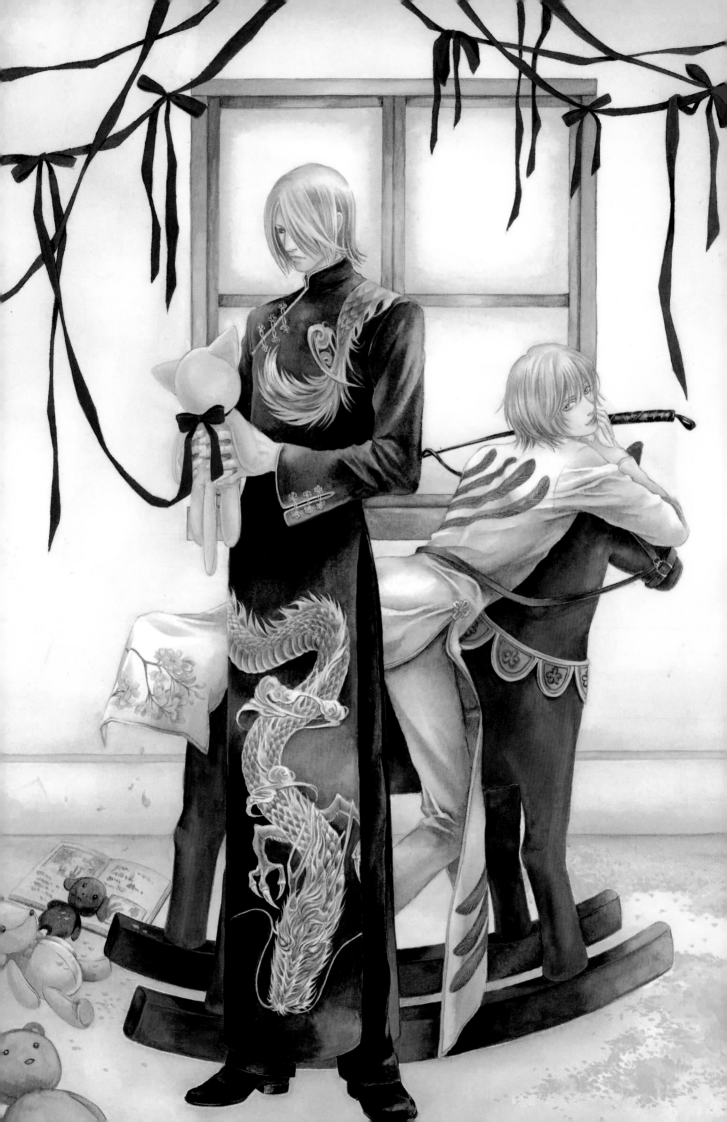

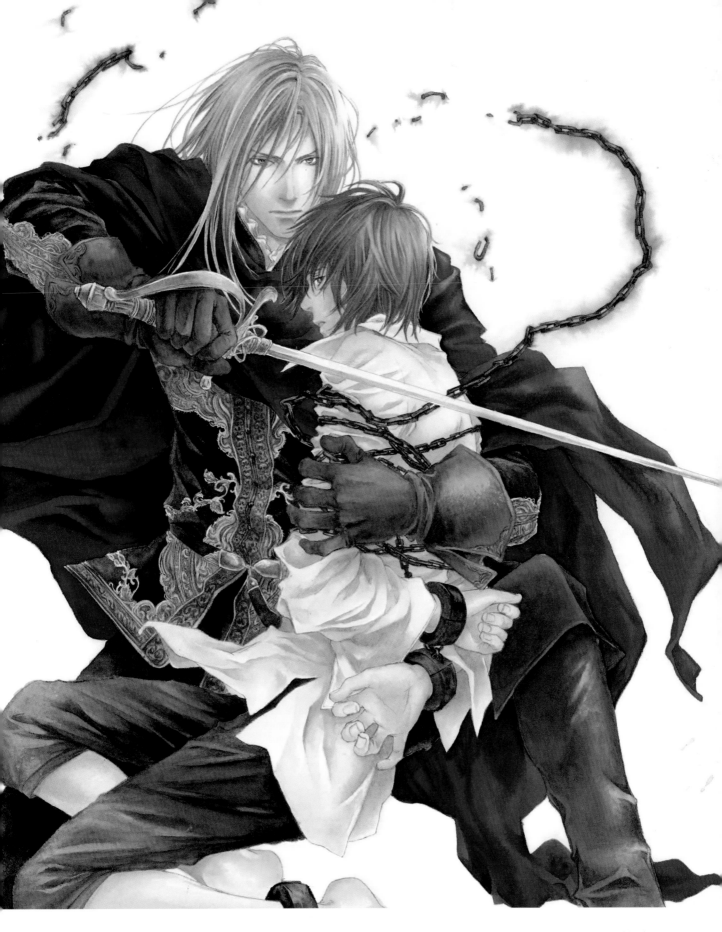

Page 84: © Bijutsu Shuppan-Sha. 2005 **Page 86:** *Nessa no tikai (Vow of Fiery Desert Sands)* cover illustration, Shogakukan Palette Bunko collection, written by Ryoka Tachibana/Shogakukan Inc., © Ryoka Tachibana, Kaoru Yukifuna/Shogakukan Palette Bunko collection, 2004. **Page 87:** *FLESH & BLOOD* Vol. 6 cover illustration, Tokuma Chara Bunko collection, written by Natsuki Matsuoka/Tokuma Shoten Publishing Co., Ltd., © Natsuki Matsuoka, Kaoru Yukifuna/Tokuma Shoten Publishing Co., Ltd. **Page 88:** *FLESH & BLOOD* Vol.7 cover illustration, Tokuma Chara Bunko Collection, written by Natsuki Matsuoka/Tokuma Shoten Publishing Co., Ltd., © Natsuki Matsuoka, Kaoru Yukifuna/Tokuma Shoten Publishing Co., Ltd. **Page 89:** *Novel Eclipse*, April 2001 issue cover illustration, Otou Shobo © Kaoru Yukifuna/Otou Shobo. **Page 90:** *CRAFT* Vol. 20 2004 cover illustration, Taiyotosho, © Kaoru Yukifuna/Taiyotosho. **Page 91:** *FLESH & BLOOD* Vol. 5 cover illustration, Tokuma Chara Bunko collection, written by Natsuki Matsuoka/Tokuma Shoten Publishing Co., Ltd., © Natsuki Matsuoka, Kaoru Yukifuna/Tokuma Shoten Publishing Co., Ltd.

STEP-BY-STEP

01 I composed a draft based on the rough sketch. Then, I drew the main lines with some water-resistant Sepia drawing ink after cleaning up the other lines.

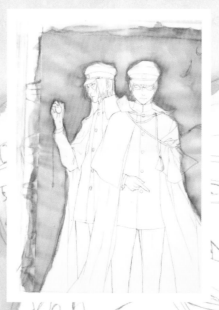

02 I applied the basic color over the entire sheet of paper to create the base of the picture, and a darker color on the background of the characters to make them stand out.

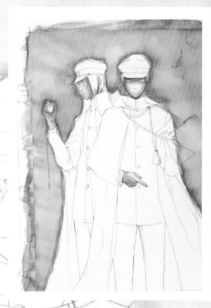

03 I also applied the basic color on the character's skin, overlapping the colors beforehand while considering the part that should be shaded.

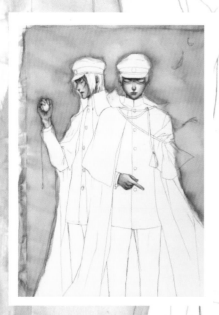

04 Then, I applied mixed watercolor paints, which were darker than the previous base color, on the shaded areas, such as the chin and the nape under the hats to complete the skin areas.

05 Next, I colored the hair after making sure that the skin color was dry. I painted the right-hand character's hair in black and the left-hand character's with a pale color.

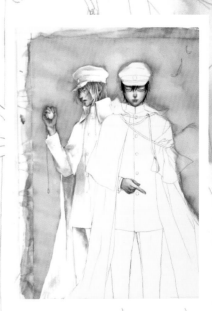

06 Then, I painted the rear left-hand character in white, since he wears a white *gakuran* (uniform for middle and high school boys in Japan). I finished the shaded area with a gray color, and used the original color of the paper.

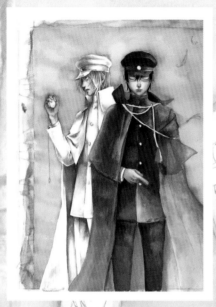

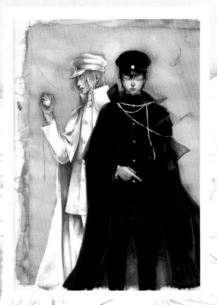

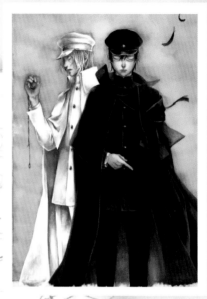

07 I applied the basic color on the main character on the right, whom I imagined to be wearing a black *gakuran*.

08 I overlapped darker colors to make them appear blacker than the basic bluish color, while considering the contrast against the adjacent white *gakuran*. Then, I applied a purplish color to the lining of the black *gakuran* to emphasize the border of the pants.

09 I painted the details, such as the pocket watch, cord, buttons, and the feathers, which accentuate the background. I unified the entire color range with sober hues to strike an overall picture balance.

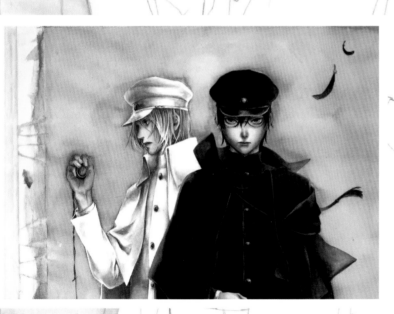

10 Finally, I colored the eyes, which are the key focus of the characters' facial expressions, the eyeglasses, and other highlights to complete the picture.

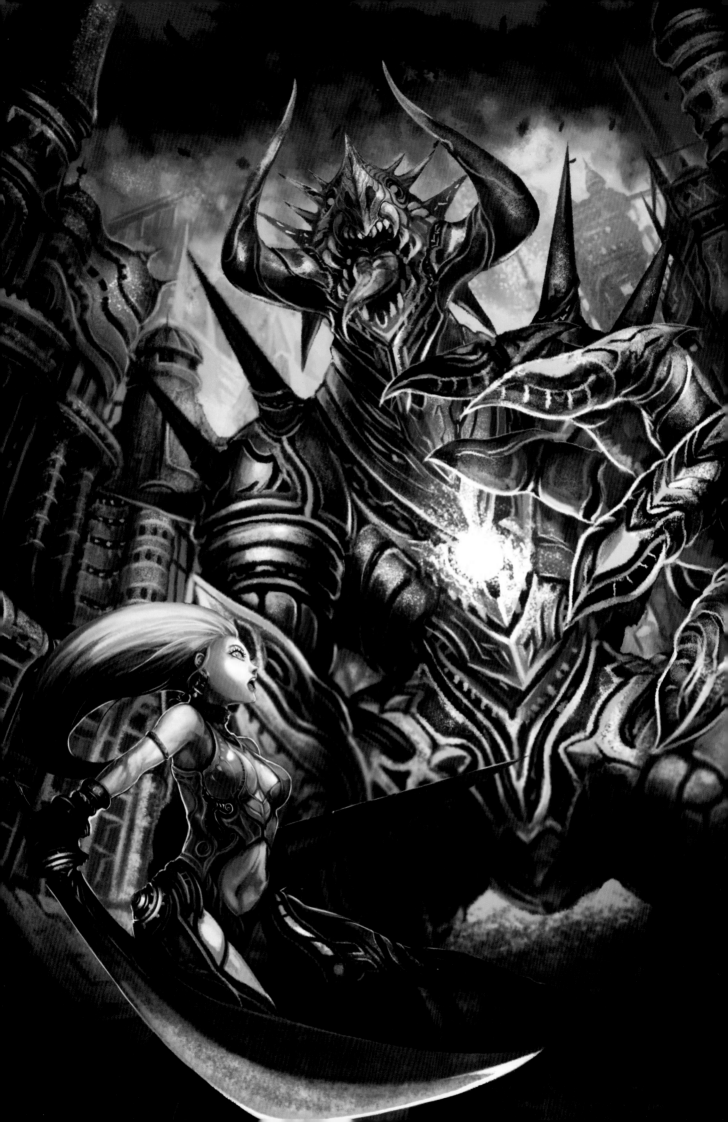

Shukei

Shukei

Shukei's theory of effective composition and coloring influences his expertise on perspective. He is an illustrator of the rare cards for the trading-card game "Duel Masters." The vigorous monsters in his fantasy world seem to leap out at you, while his use of dark colors and shadows make his illustrations daunting and powerful.

Shukei

Date of birth	: August 21, 1982
Gender	: Male
Place of birth	: Seoul, South Korea
Educational background	: Tama Art University graduate
Web site	: www6.ocn.ne.jp/~costudio/, http://costudio.biz/

Working tools

Digital

Main computer	: Windows
OS	: Windows 2000
CPU	: Pentium4 2.40GHz
Applications	: Photoshop CS
Memory	: 1G
HDD	: 365GB

Favorite artists

Fumi Saimon, Yumi Unita, Izumi Matsumoto, Yoshihiro Togashi, Enki Bilal, Renji Murata, Frank Frazetta, John Foster, Yoshinori Ohrai, Akihiko Yosida, Justin Sweet

Published works

Duel Masters, Wizards of Coast Inc. / Shogakukan Inc. / Takara Co., Ltd. / Mitsui-Kids: card illustration
Samurai Champloo, Manglove Inc.

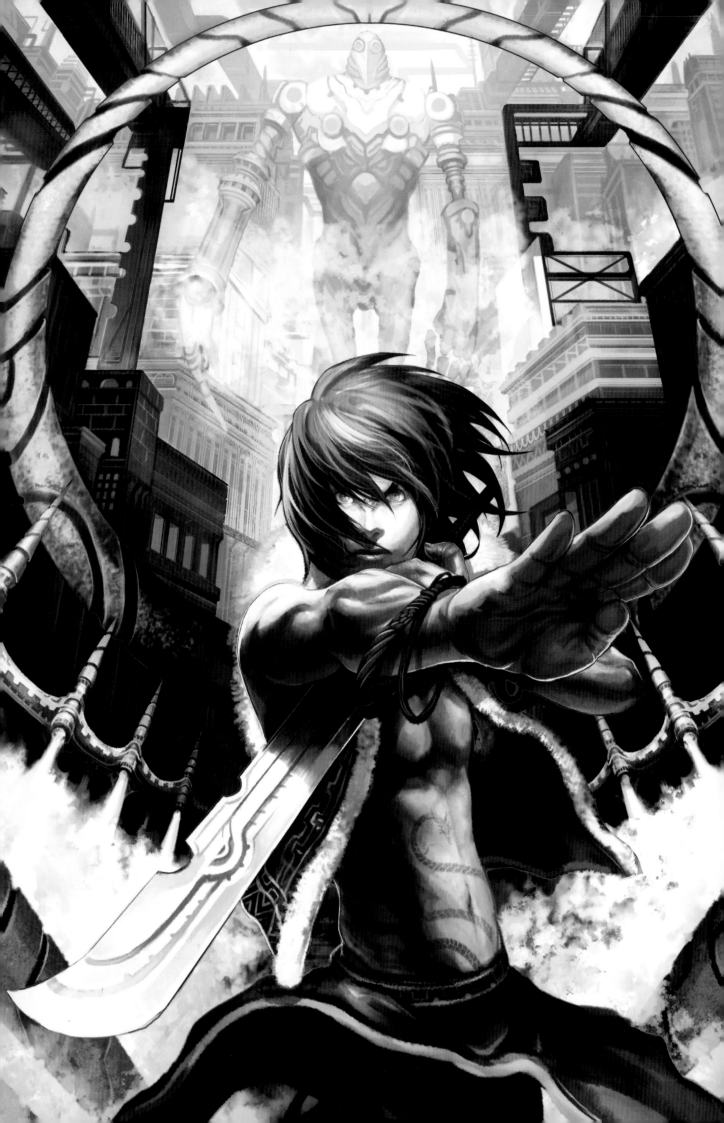

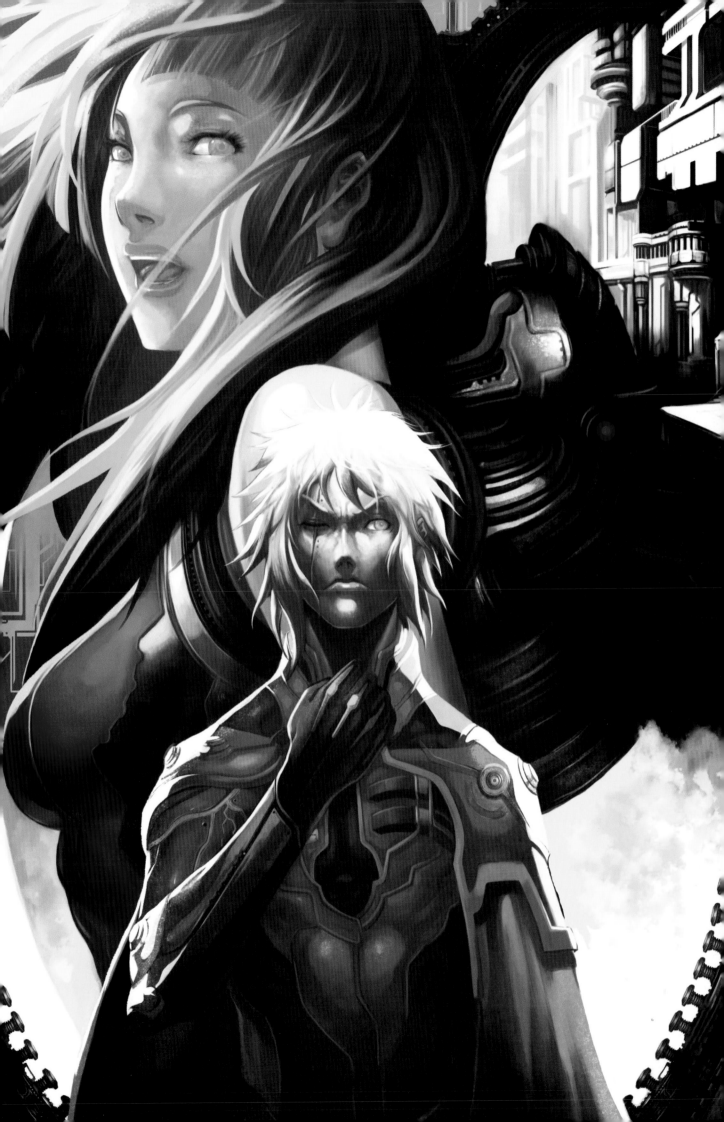

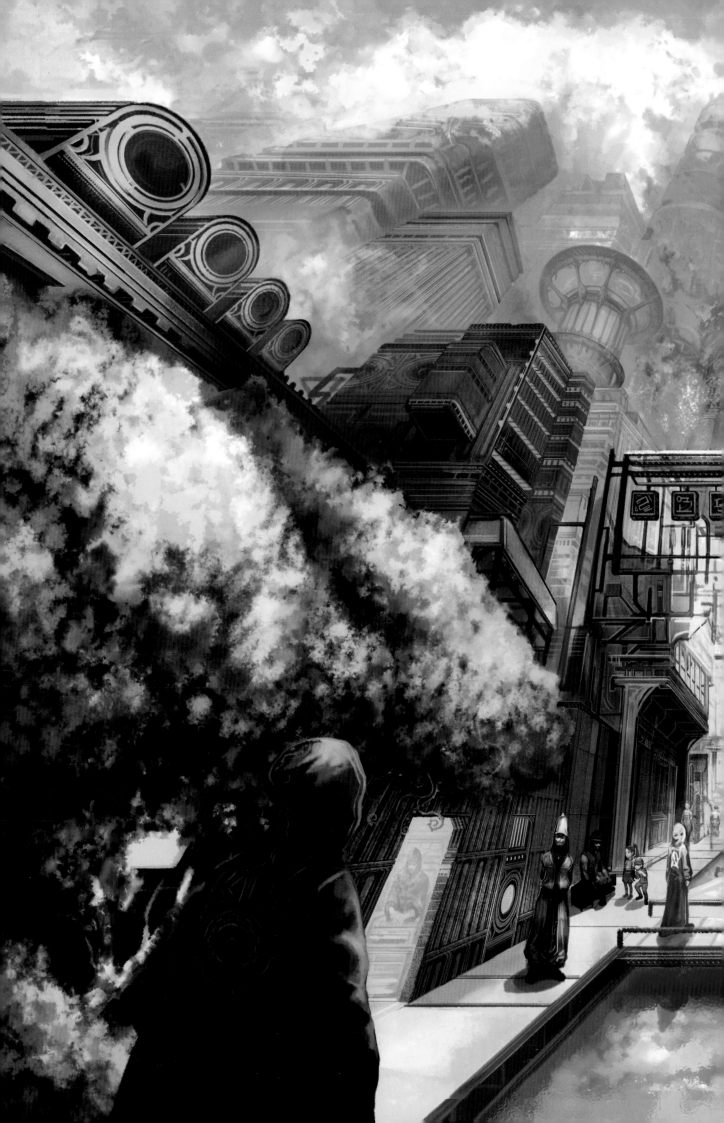

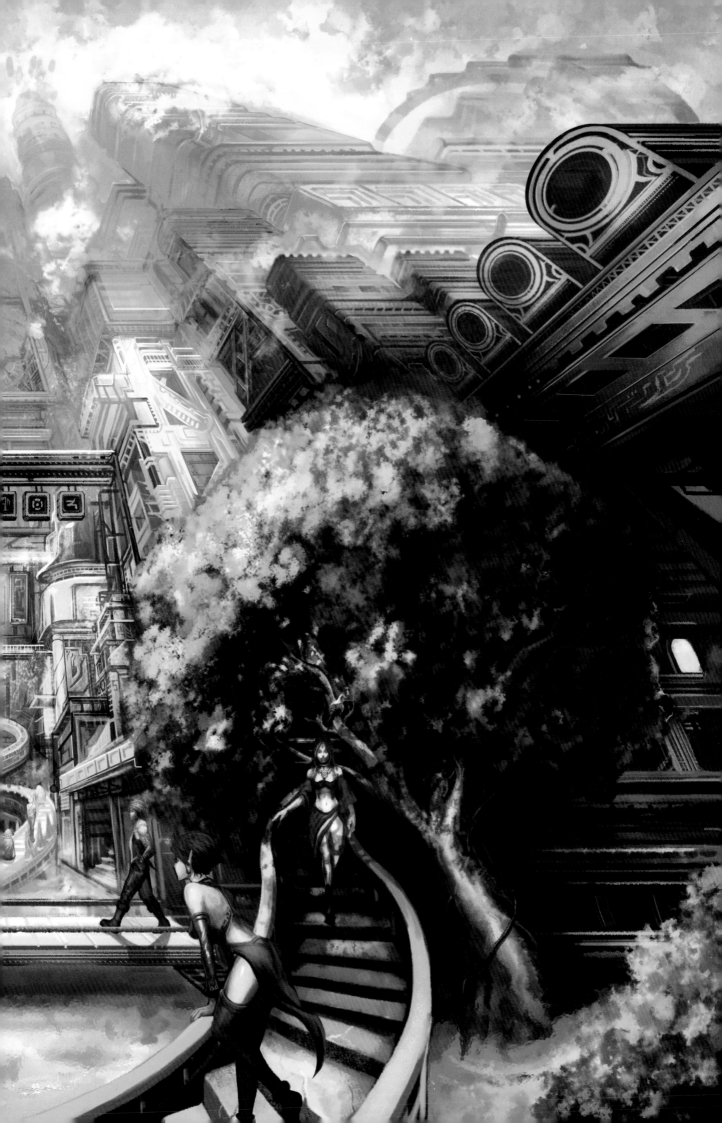

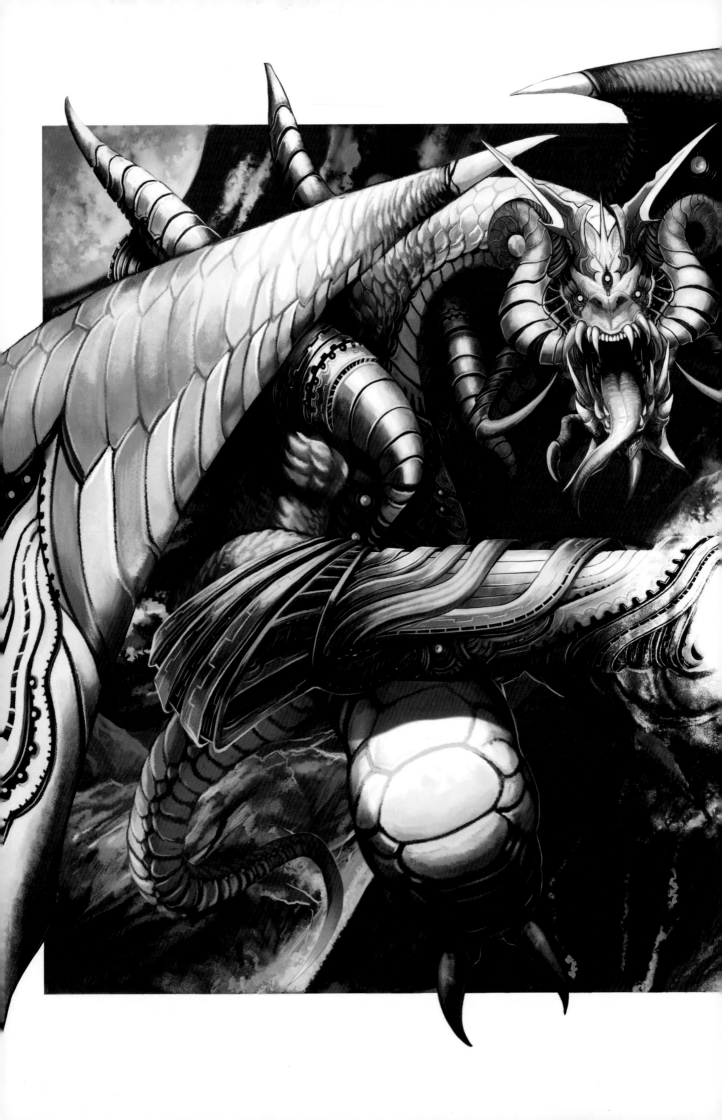

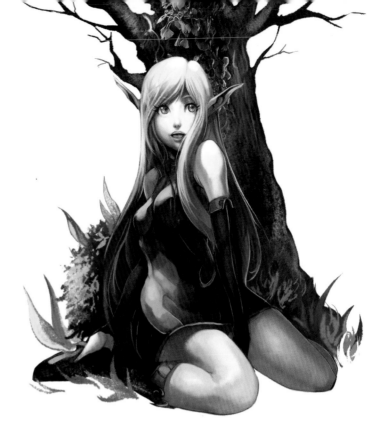

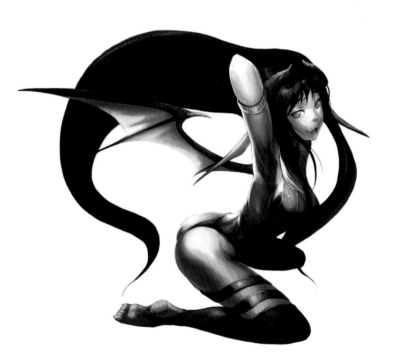

STEP-BY-STEP

01 I drew a rough sketch to grasp the atmosphere of a monster battle, instead of starting with a line drawing and coloring it, since I wanted to focus on the painting process.

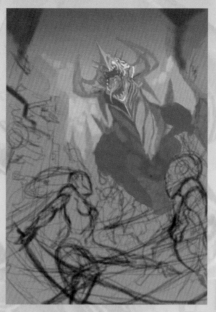

02 I applied a medium tone over the entire picture, using the "gray drawing" technique of darkening all the whitish parts. At this point, I increased the picture's overall impression.

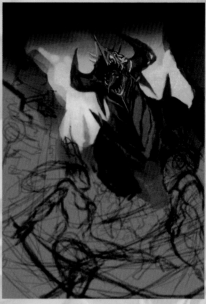

03 I colored the basic shades, and decided on the base color of the light source.

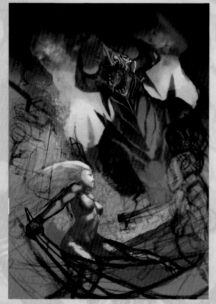

04 I painted the objects concretely by instinct, while maintaining color balance and setting the atmosphere.

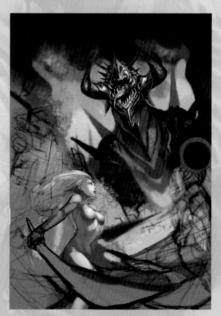

05 I started painting the visibly impressive parts, such as the face and the hands.

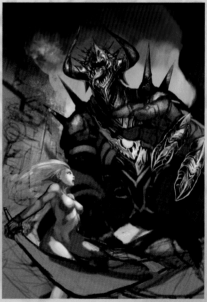

06 I planned to place the monster far behind the image, but I changed its position when I did the layout, to give the picture a feeling of tension. Although this approach made the composition appear unstable, I tolerated it. Then, I arranged a "triangle composition" among the hands in the foreground, the monster's face, and the woman.

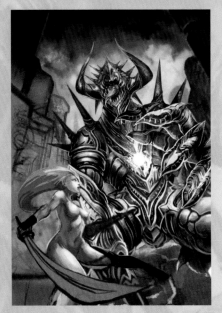 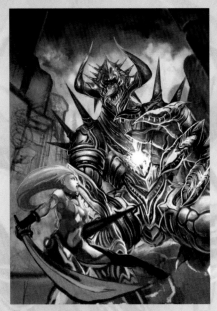 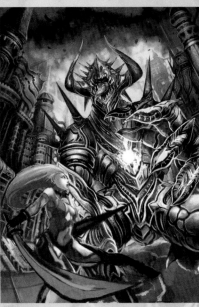

07 I painted the form of the monster, and composed the female figure.

08 I painted the woman's costume roughly. Then, I painted the monster with cold colors, and the woman with warm colors to create contrast.

09 I painted the entire background by producing a collapsed and twisted setting that appeared to be damaged by the monster, rather than by working on my usual perspective drawing.

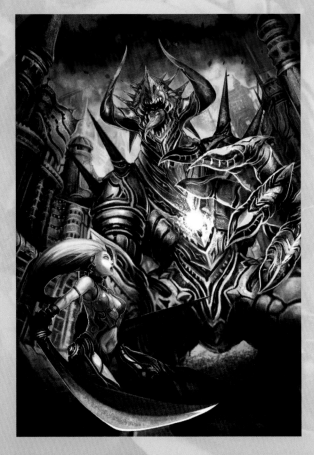

10 Finally, I painted the woman's body details more delicately than the monster's, to emphasize perspective. I defocused the monster's image since it was positioned in the background. I darkened the colors at the bottom of the picture to draw the eye to the upper part, and then, completed the work.

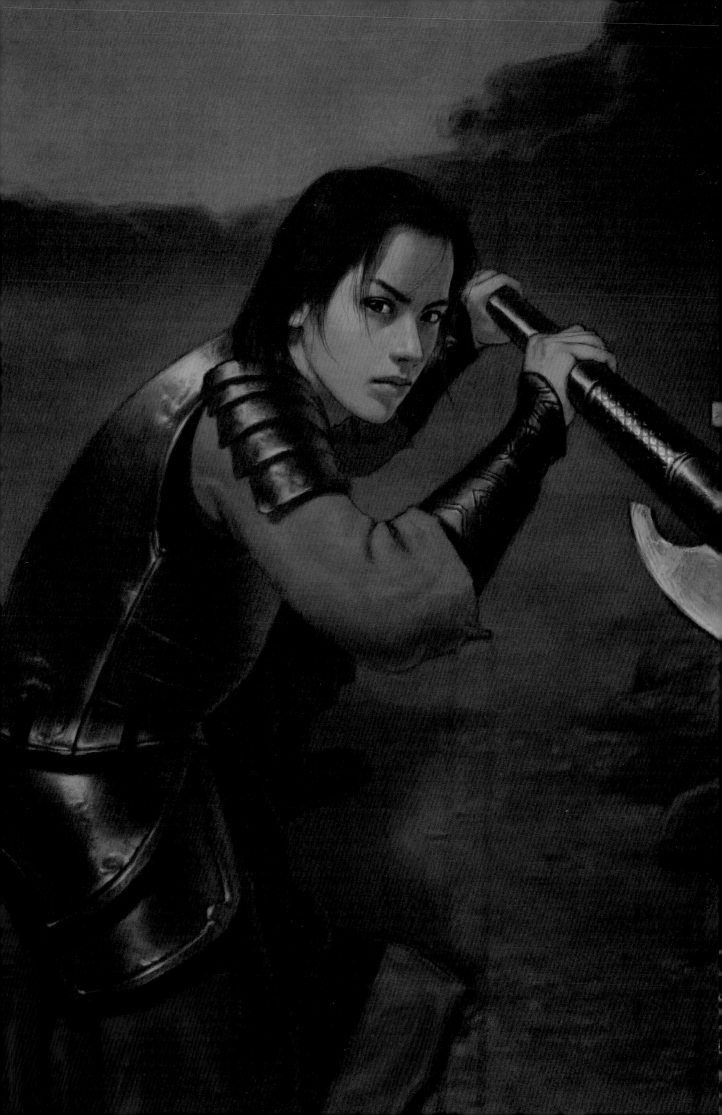

Chen Shu-Fen & Pin-Fan

陳淑芬&平凡

Chen Shu-Fen and Pin-Fan are both immensely popular for their beautiful depictions of women, not only in Taiwan but in Japan as well. Their realistic illustrations of Asian beauty are considered among the best in the world. Their individual and collaborative works are fresh, creating a crystal-like ambience.

Pin-Fan

Date of birth	: April 20, 1967
Gender	: Male
Place of birth	: Taipei, Taiwan
Educational background	: Fu-Shin Trade and Arts School
Web site	: www.pinfen.com.tw

Chen Shu-Fen

Date of birth	: December 23, 1967
Gender	: Female
Place of birth	: Taipei, Taiwan
Educational background	: Takming College graduate
Web site	: www.pinfen.com.tw

Working tools

Main computer	: Macintosh
OS	: OS X
CPU	: G5
Application	: Painter
Memory	: 8G
HDD	: 1000GB

Working tools

Main computer	: Macintosh
OS	: OS X
CPU	: G5
Application	: Painter
Memory	: 4GB DDR SDRAM
HDD	: 1000GB

Favorite artists

Natsuki Sumeragi, Mike Mignola, Dave Mckean, John J. Mush, Katsuhiro Otomo, Bromsimon Bisley, Katsuya Terada, Renji Murata, Kazuma Kaneko

Favorite artists

Natsuki Sumeragi, John J. Mush, Reiko Okano, Fuyumi Souryou, Kazumi Yamashita, Norman Rockwell, Yoshitaka Amano, Yumi Tada, Renji Murata, Naoki Urasawa

Published works

PINFAN Private Collection, Tohan Co., Ltd. Taiwan branch. February 2005
S Quarterly magazine, Asukashinsha Co.
Action, Hutabasha Publlishers Ltd., first issue until January 7, 2005 issue; cover design
Yellow, White, Blue, Red color series, Shogakukan Production Co., Ltd.; story book illustration

Published works

My Birthday monthly magazine, Sharp Point Publishing Co., Ltd.,1995-2004; cover design
S quarterly magazine, Asukashinsha Co.
Action, Hutabasha Publlishers Ltd., first issue until January 7, 2005 issue; cover illustration
Yellow, White, Blue, Red color series, Shogakukan Production Co.,Ltd.; cover illustration
Chen Shu-Fen + Pin-Fan Private Collection II /Sweet Days, Shogakukan Production, 2004

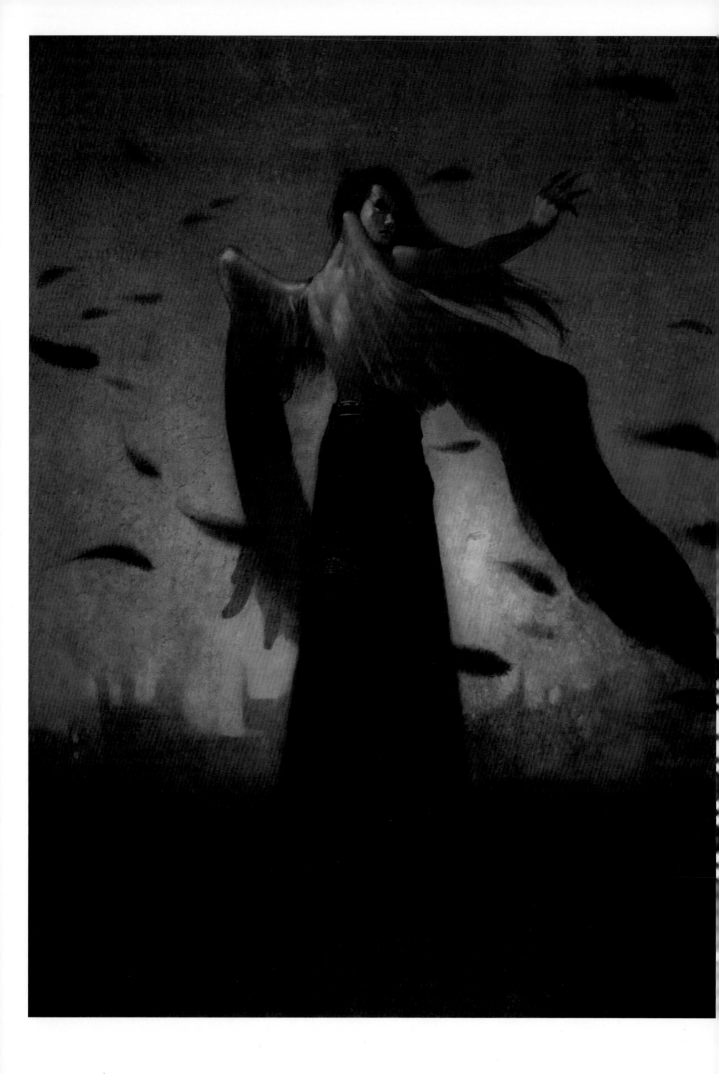

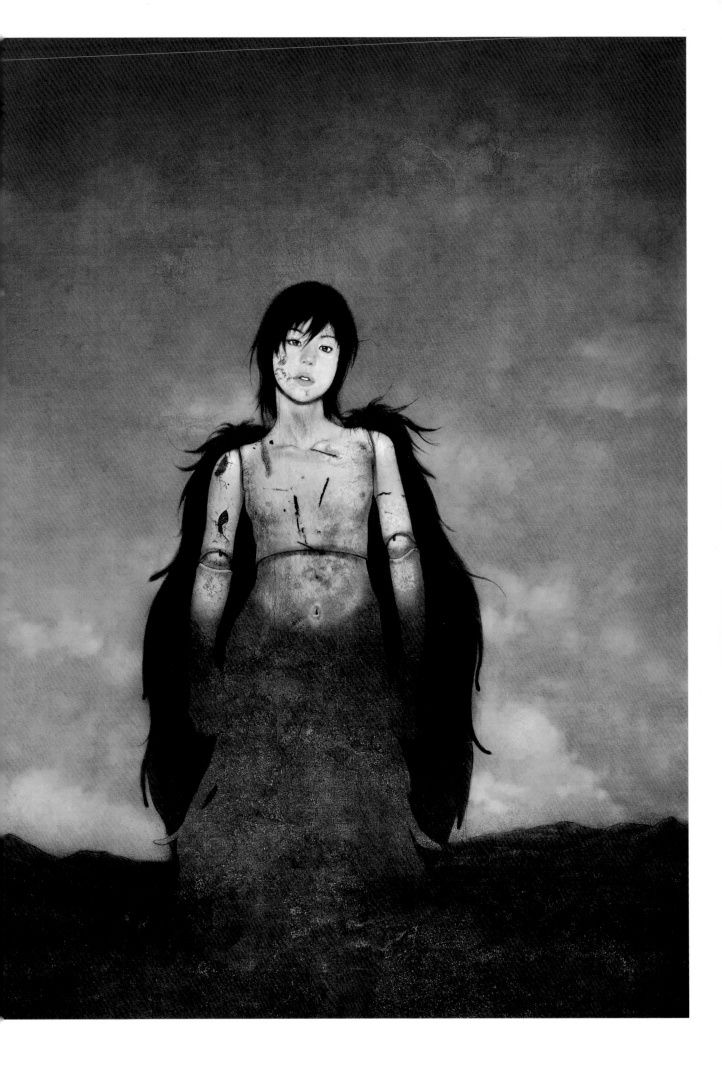

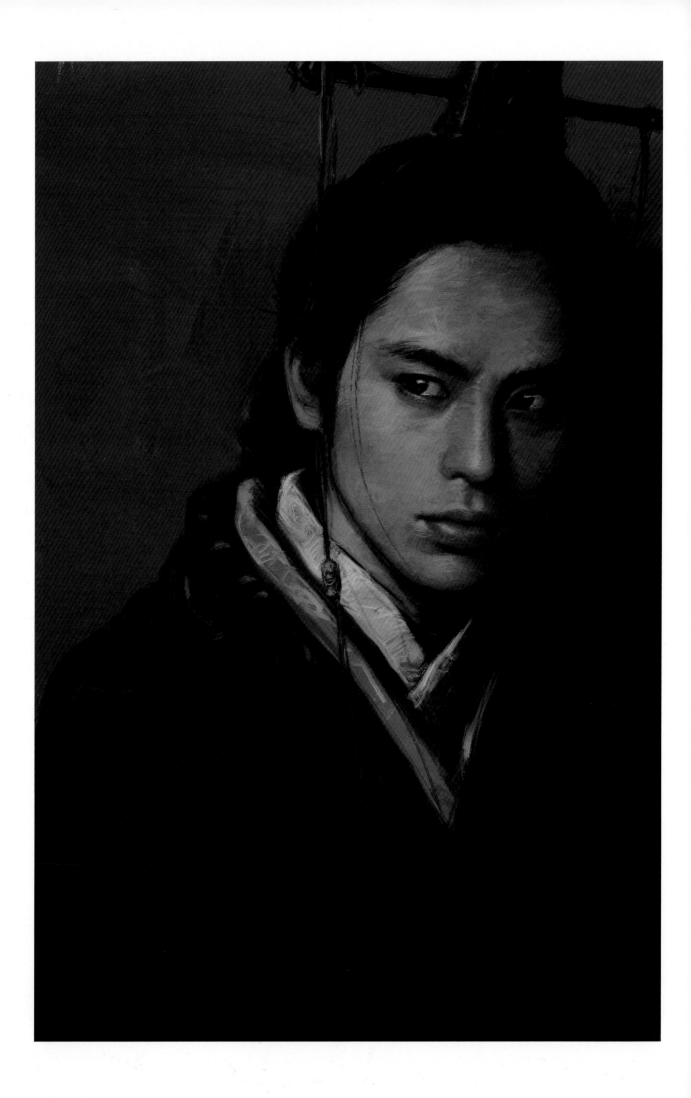

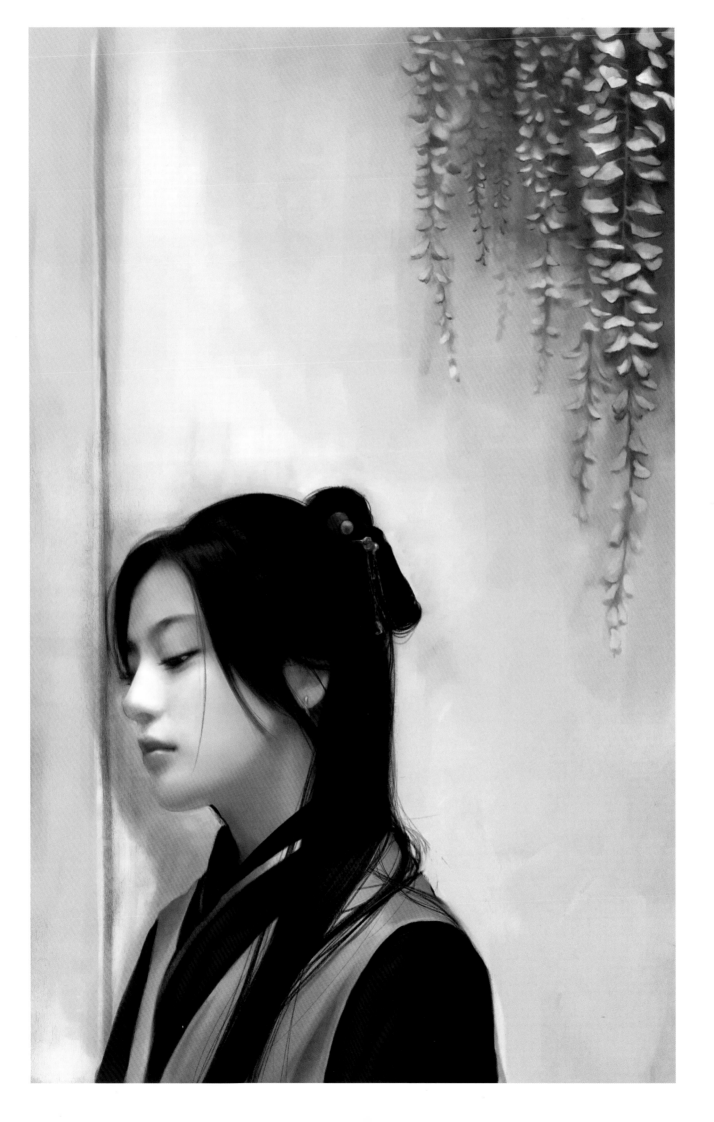

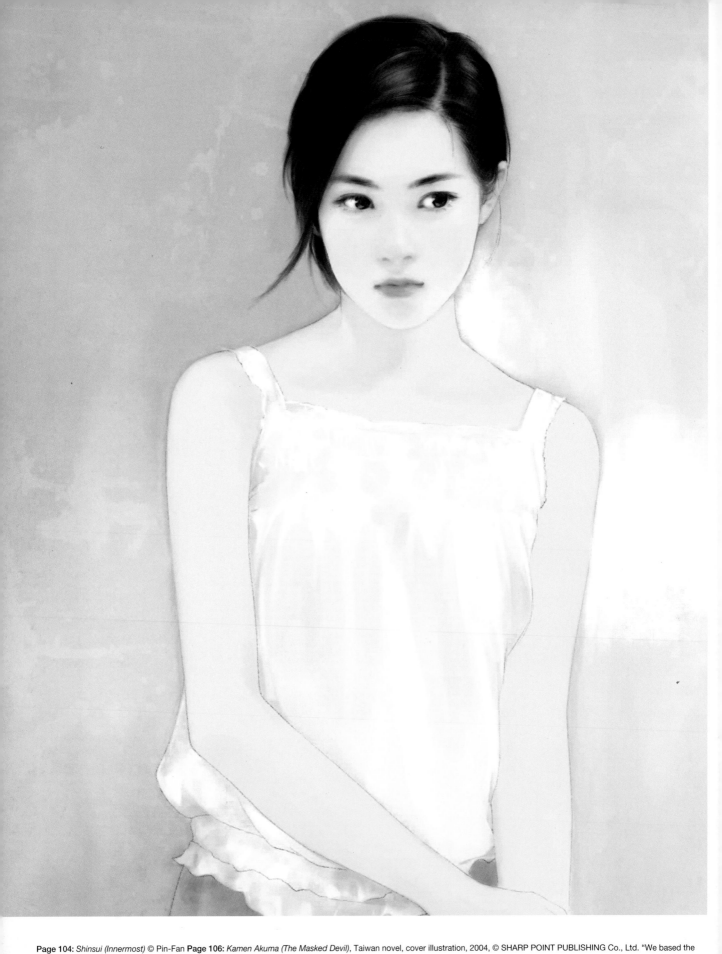

Page 104: *Shinsui (Innermost)* © Pin-Fan **Page 106:** *Kamen Akuma (The Masked Devil)*, Taiwan novel, cover illustration, 2004, © SHARP POINT PUBLISHING Co., Ltd. "We based the composition on the theme of the novel, and imagined a movie scene. The center of light and shade was set in the background, and we wanted to express the feeling of the 'devil's advent.'" **Page 107:** *Doll*, "PIN-FAN Private Collection" portfolio, cover illustration, 2005, © TOHAN, Co., Ltd/Taiwan branch. "The doll's body is covered all over with wounds, and emotes feelings parallel to ours. It had always been manipulated, and unable to do what it wanted, so it lost its vigor and was, consequently, isolated in the wilderness." **Page 108:** *Kikoushi (Young Nobleman)*, Taiwan novel, cover illustration, 2004, © SHARP POINT PUBLISHING Co., Ltd. "The character is a nobleman and became a victim of a power struggle that he lost in court. He grew up in an oppressive and closed environment. He looks gloomy, and always complains and suspects other people." **Page 109:** *Shinjou (Profound Feeling)*, Taiwan novel, cover illustration, 2004, © Homer Books and Records Inc. "A woman is waiting sorrowfully and vainly under the hydrangea flowers for her unrequited lover to pass by. She is not brave enough to confess her feelings, hence, she always watches him secretly." **Page 110:** *Muku (Innocent)*, Taiwan novel, cover illustration, 2003, © Homer Books and Records Inc. "Originally, there was a lotus flower in the background, but when we were commissioned to paint a troubled lovely girl, we chose a blank background composition instead for the actual novel's cover version in order to emphasize the beautiful girl." **Page 111:** *Miren (Lingering Attachment)*, Taiwan novel, cover illustration, 2003, © Homer Books and Records Inc. "We wanted to express the girl's lingering attachment to her boyfriend who lives far away, even after she reunited with him."

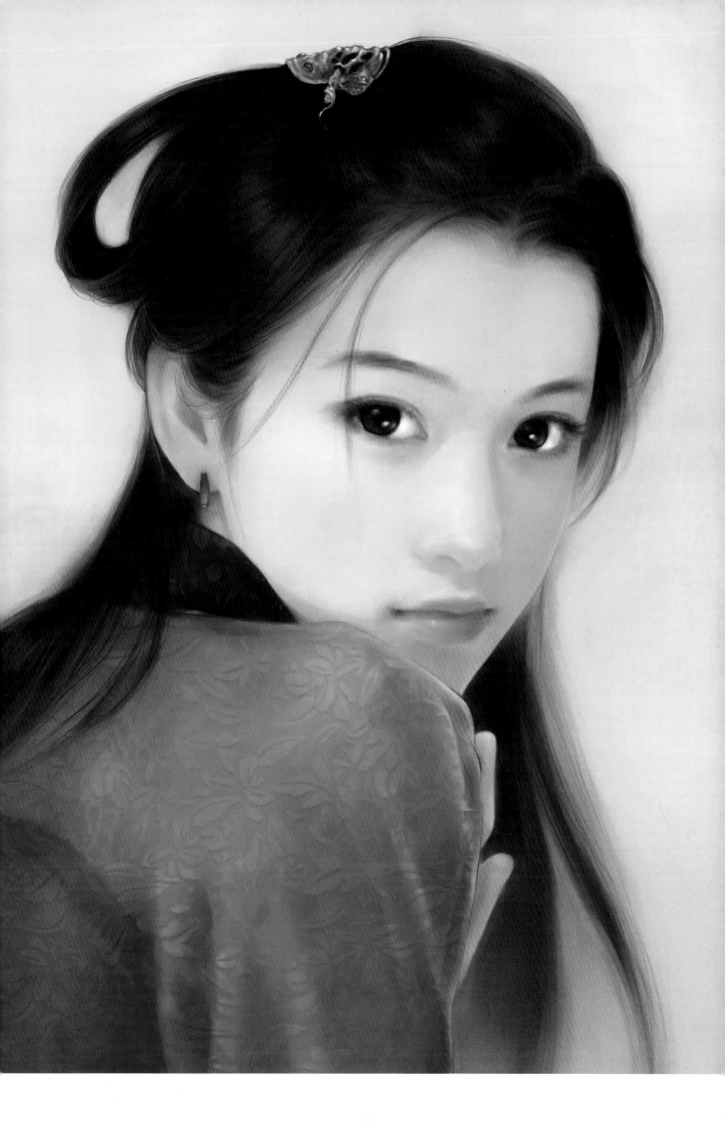

STEP-BY-STEP

01 We drew a rough sketch while considering the entire composition.

02 We created bright and dark effects on the line drawing using watercolor brush tools to decide the light direction.

03 We applied a dark blue gray color for the entire base of the picture, and added light and shade to the character's face. We used a layer to simulate the impression of an oil painting, and a screen mode to produce an inverse effect. With this mode, we did not have to use brighter colors to attain the intended result.

04 We merged the first layers and opened a new layer. We colored repeatedly until the desired outcome was met. At this stage, we completed coloring most of the light and shade on the face.

05 We also applied light and shade to a part of the clothes, then added detail to the previously shaded part of the face.

06 We created a backlight effect on the external side of the face to emphasize its outline. We stopped coloring it at this point in order to consider the entire color tone.

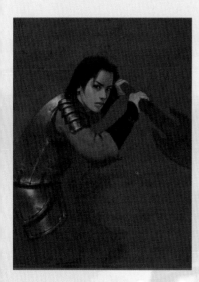

07 We started to color the armor extensively by paying careful attention to the light reflections on the metal. We drew the dents delicately to make them appear realistic, then, colored them.

08 We left the armor in this state, and started to paint the sleeves as roughly and easily as possible, since we had already added the light and dark effects as desired.

09 We painted the spear, which faced to the front. We had to carefully illustrate the light and dark parts according to the perspective. We also paid attention to the light reflection on the spear by enhancing the picture with contrast.

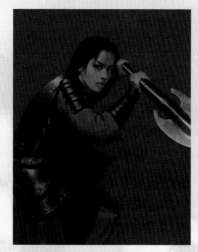

10 We painted the stick smoothly with the same sense used for illustrating the spear. We applied an indigo blue backlight to the spear to create a metallic texture, and added heaviness to the armor. We detailed the leather objects and the boots, and treated the tone differences of the hair naturally.

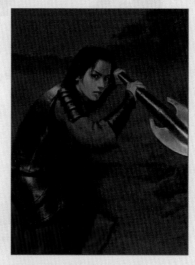

11 We started to paint the background by repeatedly using layers as in the previous steps, and added contrast and color to the picture, while considering the overall balance.

12 Finally, we painted the sky by venturing on a bright color to stabilize the entire picture balance. We modified some details and completed the work.

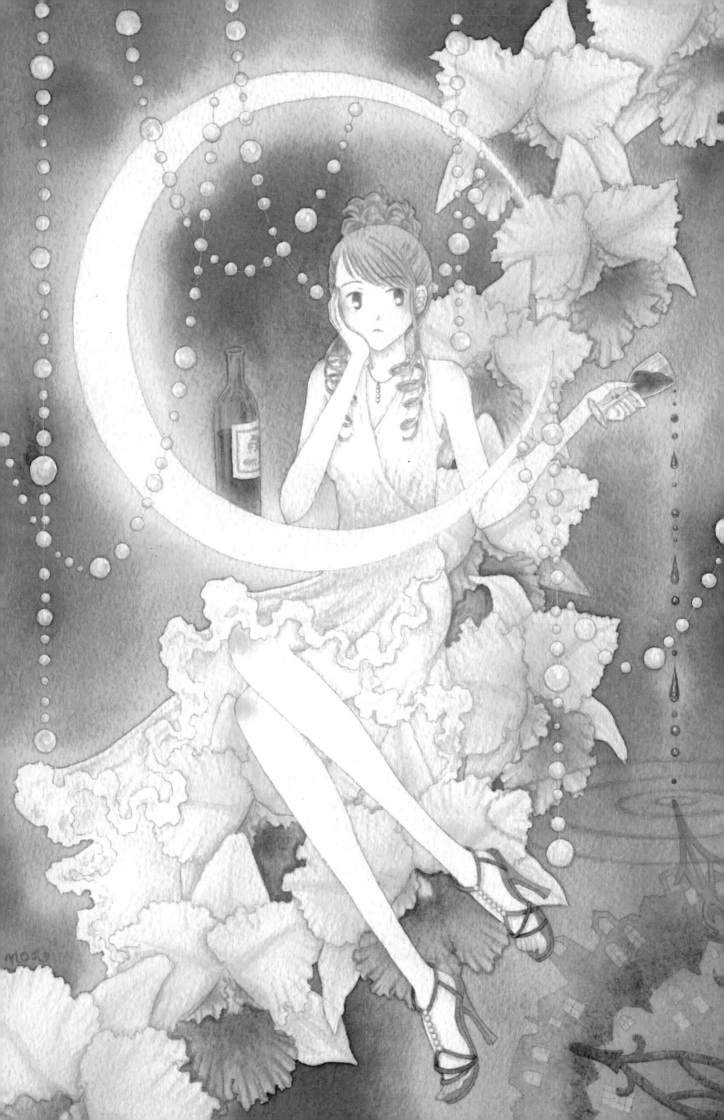

noa

noa

noa creates a tender world by coloring mainly with transparent watercolor paints, and pastels for accents. Her delicate lines and sophisticated coloring style create a soft, feminine impression, which along with the floral and fairy-like imagery throughout, give a sense of warmth and happiness.

noa

Date of birth	: November 18
Gender	: Female
Place of birth	: Tokyo, Japan
Educational background	: Teikyo University, Department of Pharmacy
Web site	: http://smile.poosan.net/hana-gasumi/

Working tools

Hand Drawing and Painting

Paper	: Arches watercolor paper/smooth
Coloring	: HOLBEIN transparent watercolor
Brush	: Sekaido original brushes
Pen & Pencil	: Copic multiliner .03mm, .05mm Sepia, 0.3/HB mechanical pencil

Favorite artists

Hayao Miyazaki, Junko Kitano, Keibun Ota, Takashi Yanase, Fumiko Tanikawa

Published works

Comickers Illustration Masters Exhibition Club C's Door winter issue, Bijutsu Shuppan Sha Ltd., 2004
A book is what you write, White pages, Monogatari Kobo, 2004: supplemental postcard design
Step-By-Step illustration pages for *SS* May issue, 2005. Asukashinsha Co.
Editorial illustration for *Shi to Märchen (Poem and Märchen)*. Sun Rio Co., Ltd.

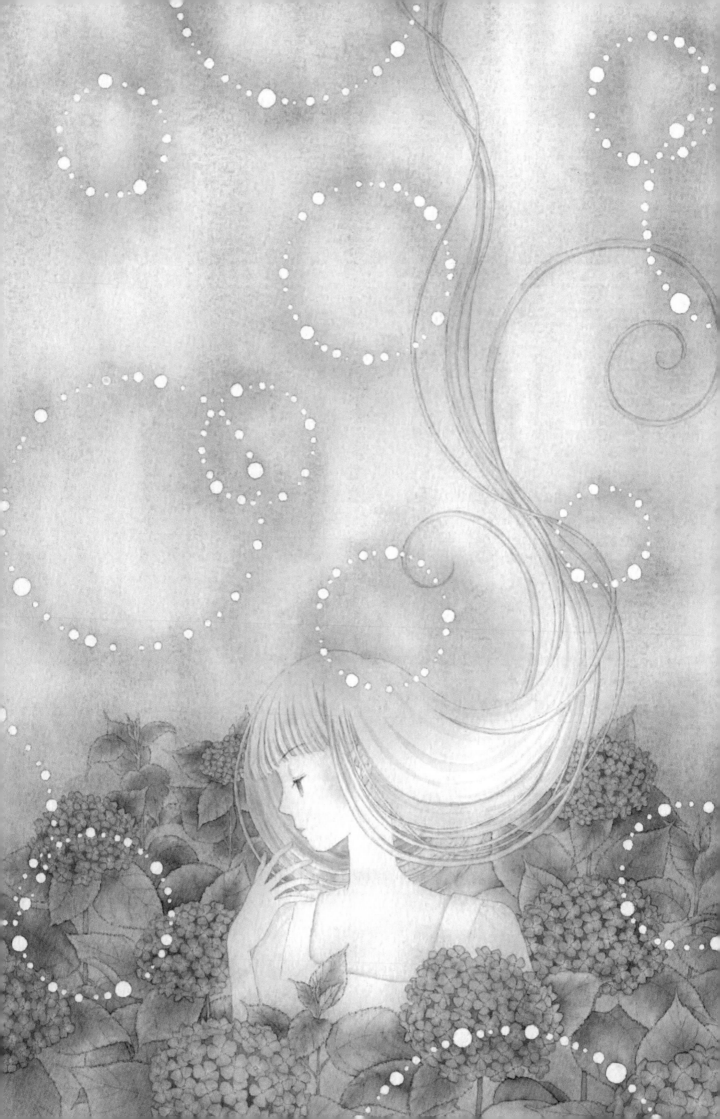

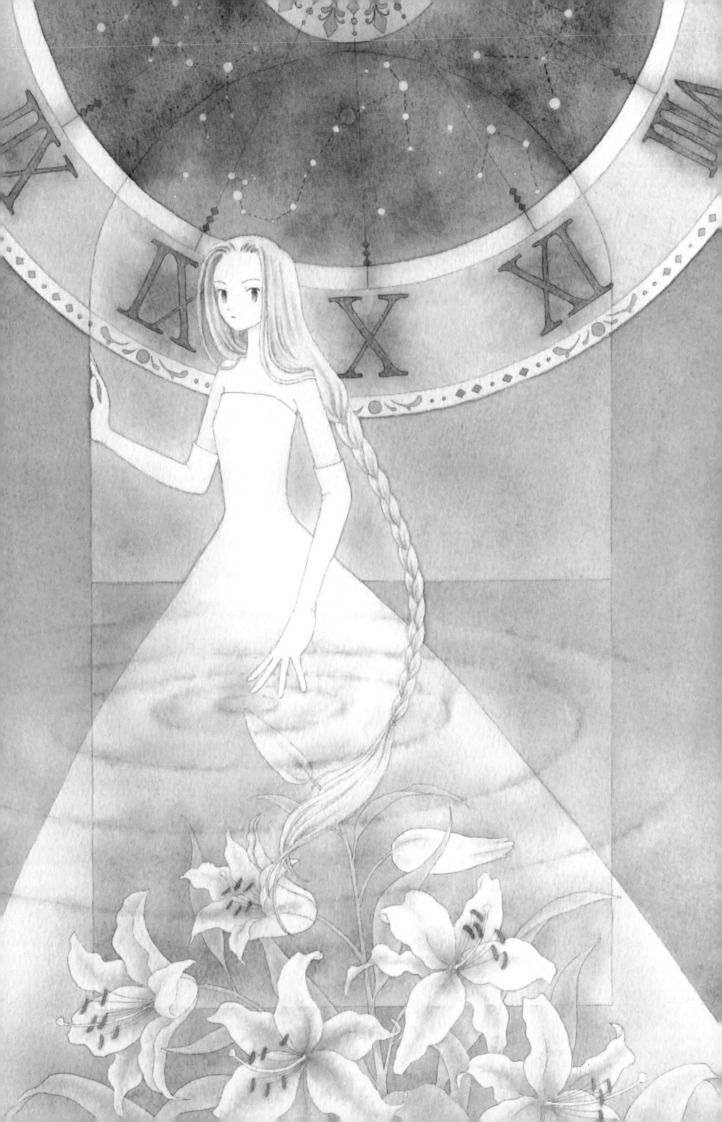

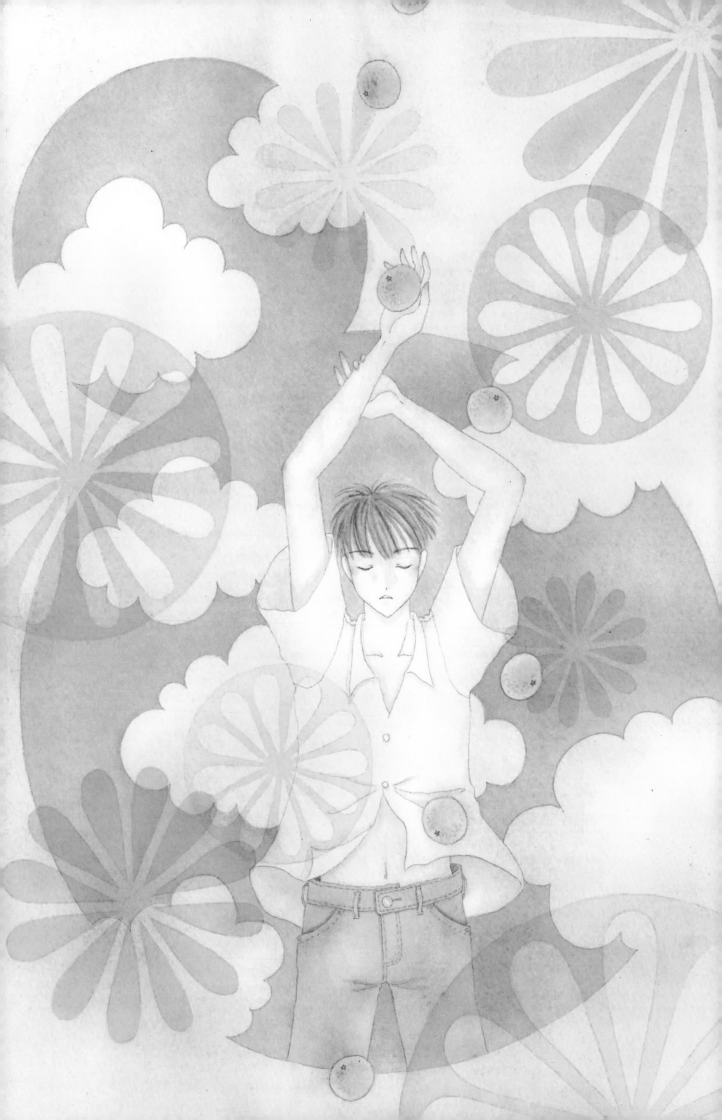

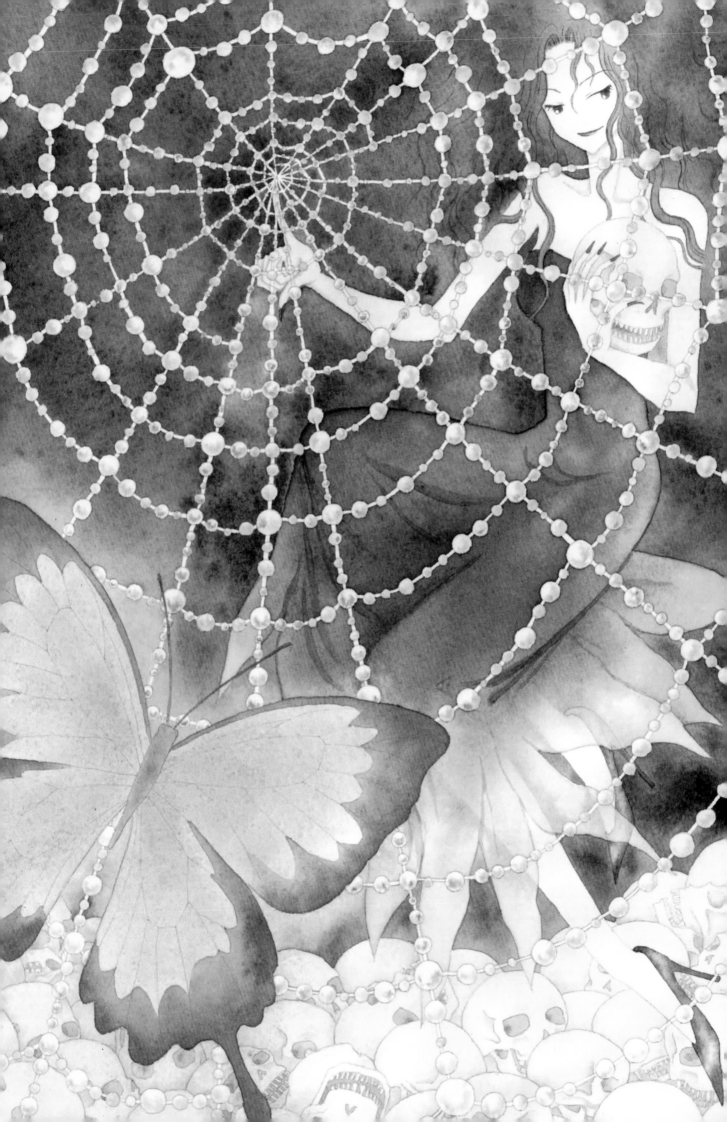

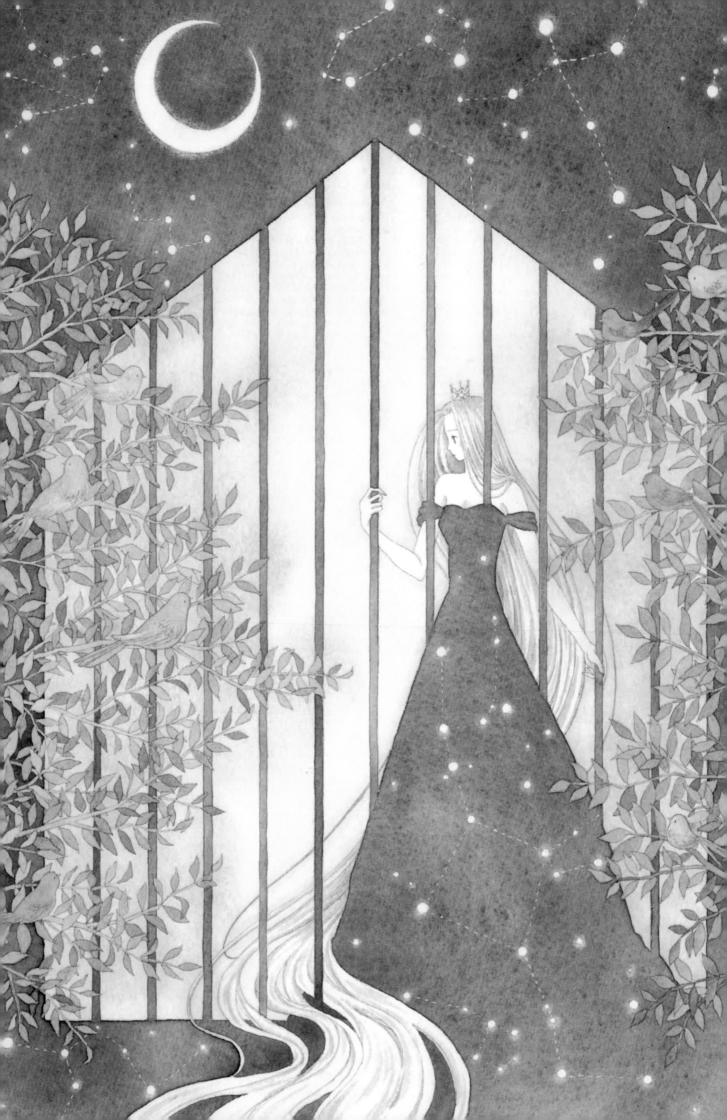

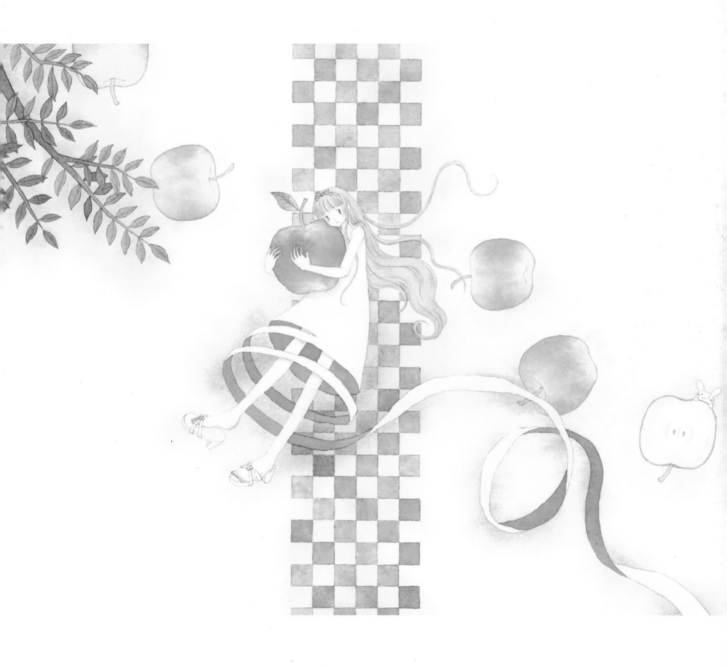

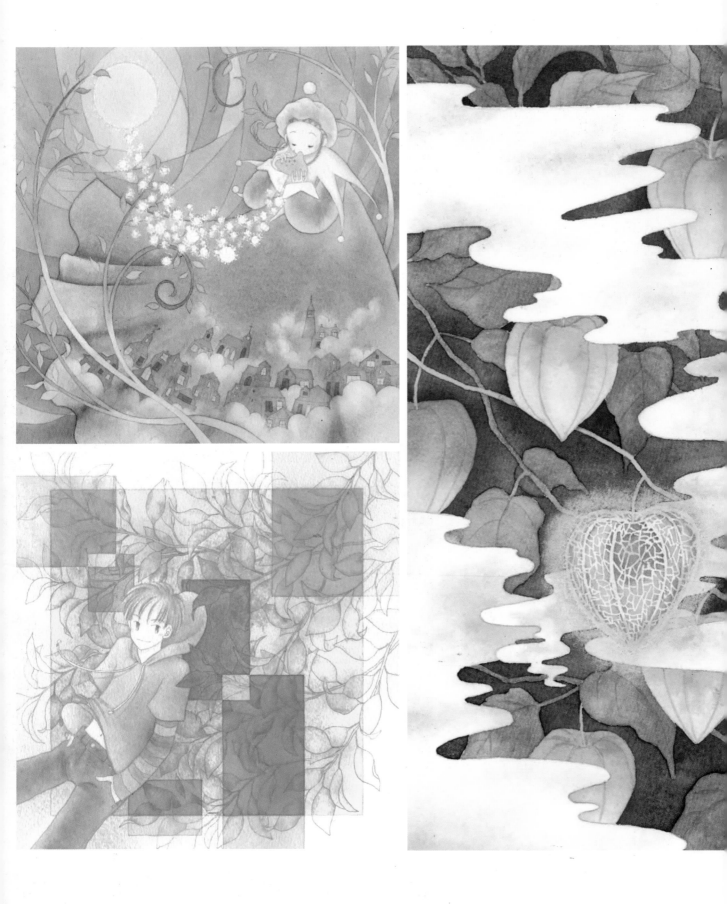

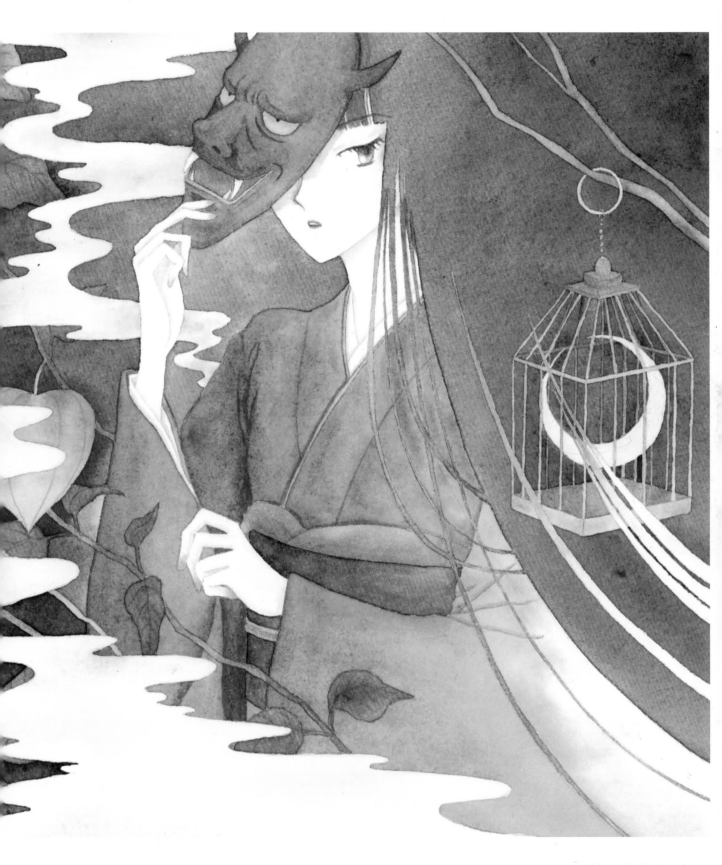

Page 114: *Tsukiyo no Kyouen (Moonlit Night Feast)*, newly painted illustration. "I tried to convey a gorgeous and romantic mood." Page 116: *Ajisai Iro no Ame (Hydrangea Color Rain)*, quarterly magazine *Comickers* winter 2004 issue, the 36th Illustration Masters Exhibition, © Bijutsu Shuppan-Sha. "I painted the damp expression of a rainy day." Page 117: *Ketsui (Determination)*, quarterly magazine *Comickers* winter 2004 issue, Club C's, title page illustration, © Bijutsu Shuppan-Sha. "I gave the picture a mysterious atmosphere by featuring a dignified girl among transparent lilies." Page 118: *Citrus * Citrus*, quarterly magazine *Comickers* autumn 2004 issue, the 40th Illustration Masters Exhibition, © Bijutsu Shuppan-Sha. "I created a citrus pattern to make the picture lively and refreshing." Page 119: *Sokubaku no Yami (Darkness of Restraint)*, quarterly magazine *Comickers* winter 2005 issue, the 41st Illustration Masters Exhibition, © Bijutsu Shuppan-Sha. "I wanted to paint the beauty of water drops on a cobweb." Page 120: *Torikago (Bird Cage)*, quarterly magazine *Comickers* autumn 2004 issue, 40th Illustration Masters Exhibition, © Bijutsu Shuppan-Sha. "The picture shows a captured princess." Page 121: *Ringo (Apple)*, quarterly magazine *Comickers* summer 2003 issue, 35th Illustration Masters Exhibition, © Bijutsu Shuppan-Sha. "I especially like the effect of the apple's skin being peeled off in the woman's skirt." Page 122, top: *Tsuki no Neiro (Tone Of The Moon)*, quarterly magazine *Comickers* winter 2004 issue, the 37th Illustration Masters Exhibition, © Bijutsu Shuppan-Sha. "I wanted to express the sound of the ocarina melting into the moon against the grain of light." Page 122, bottom: *Wakaba no Kisetsu (Season of Young Leaves)*, quarterly magazine *Comickers* summer 2004 issue, the 39th Illustration Masters Exhibition, © Bijutsu Shuppan-Sha. "I used various shades of green to express the feeling of radiant green leaves." Page 123: *Yume Monogatari (The Dream Vision)*, quarterly magazine *Comickers* spring 2004 issue, the 38th Illustration Masters Exhibition, © Bijutsu Shuppan-Sha. "I wanted to paint a scene of Chinese lanterns lit up."

01 I sketched a draft on A4 paper that was the same size used for the final work. Simultaneously, I drew the background and props to check the overall balance.

02 I pasted a piece of fine Arches watercolor paper damply on the panel board for the coloring stage. I arranged the draft lines, traced them on tracing paper, and outlined them carefully using Sepia Copic Multiliner 0.03 and 0.05 pens. I chose Sepia pens for drawing the main lines to avoid upsetting the thin watercolor tone.

03 I applied Masket Ink to the parts that I wanted to leave in white, and colored the background by mixing Holbein Rose Madder, Permanent Red, Mineral Violet, and Sepia transparent watercolor paints after the ink dried completely.

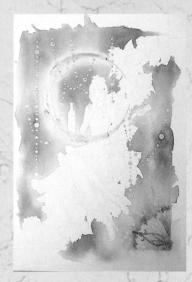

04 After the background dried, I removed the ink from the part that I wanted to color.

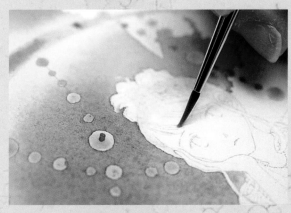

05 I applied color on the character's hair starting with the light tones, by mixing Mars Yellow, Burnt Umber, and Sepia paints with a rather large amount of water for creating the base. I do not usually paint the detailed parts, like the hair, with a single color.

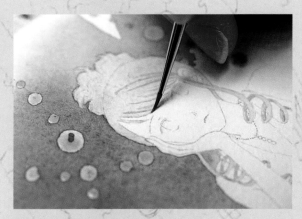

06 Then, I added Burnt Umber paint to the palette to strengthen the color hue, and tried to apply it also on the external frame. Next, I shaded the hair.

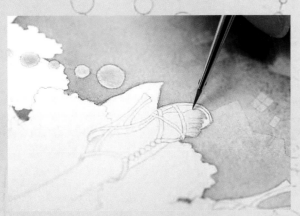

07 Rather than applying color to the paper, I used the white areas to illustrate the skin of the character's face and arms and added accents on the cheeks using a water-diluted Cadmium Red paint. I used a single color for highlighting the reddish skin, rather than blending many colors, to avoid producing a muddy appearance.

08 I applied water as base for the cattleya flower found behind the character, using a large, saturated wash brush.

09 I painted the stick smoothly with the technique used for illustrating the spear. I applied an indigo blue backlight to the spear to create a metallic texture, and added heaviness to the armor. I detailed the leather objects and the boots, and treated the tone differences of the hair naturally.

10 I used a fine brush to shade the picture after the flower section dried.

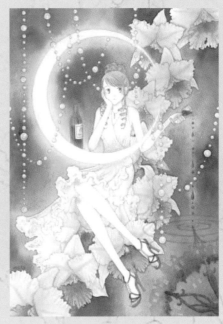

11 Finally, I painted the details and completed the work after removing the Masket Ink.

Glossary

acrylic gouache

Water-soluble acrylic paint that dries quickly and becomes water-resistant. Its strong, adhesive properties produce an even, opaque matte surface.

acrylic paint

Resin-based paint that can be diluted with water and becomes water-resistant when it dries. Highly adhesive, it can be applied not only to paper, but also to wood, stone, and cloth.

aquarelle

Highly transparent watercolor paint that can be applied in overlapping layers revealing the intricate details of the base color. It has an attractive color quality that uses the soaking and gradation method

COMITIA

The Original Independence Comic Exhibition, held four times a year. It releases and exhibits original, independently published comic books and arranges secondary events, such as exhibitions of artists' original drawings and juried contests. COMIKET, the most popular comic convention in Japan, is a different association.

color ink

Water-soluble ink that provides bright, vivid, highly saturated colors. It comes in typical brands, such as Holbein, Windsor & Newton, and Dr. Ph Martin's.

copic

Fast-drying, double-ended, non-toxic markers from Too Co. They are refillable, fit into a special airbrush system, have replaceable nibs, and are toner compatible. The standard marker type has broad and fine nibs and comes in 214 colors. Copic sketch (comprising of 310 colors) has a watercolor-touch brush nib.

copyright works

Works and characters protected by copyright law. It also applies to such material protected by copyright as fan fiction and fan art.

doujin

People with the same objectives or hobbies; also amateurs who belong to clubs and create magazines about their particular interests. Some semi-professionals, called full-time coterie, make their living by selling doujin magazines.

doujinshi

Booklets edited and published by people (usually amateurs) who share the same principles, objectives, and trends. Original works, such as independently published manga and novels, are also called doujinshi.

Duel Masters

A collectable card game sold by Takara Co. Co-developed by Wizards of the Coast, Inc., which also introduced the popular card trading game, *Magic: The Gathering*, and Shogakukan Inc., which published *Coro Coro Comics*. Duel Masters is a craze among elementary school boys who "duel" with each other while displaying their command of the creature and magic charm cards. Collecting the cards is also part of the fun.

G-pen

The recommended pen for drawing strong and weak lines according to the pressure applied. It also provides a wide range of thicknesses, from very fine to super-broad. Often used by manga artists and illustrators.

gakuran

Term commonly used for Japanese boys' school uniforms with standing collars. The long tunic worn by boys is called *choran*; the short tunic is called *tanran*. The straight-type pants are called *dokan*, and those that gradually narrow toward the hem are called *bontan*. Although not seen often recently, some blazer-type uniforms exist. This standing-collar style represents the school uniforms worn in the past.

Illustrator

Graphics application software from Adobe Systems Inc. used for designing graphics, such as logos, symbols, and layouts. It also employs a Bezier curve for illustration.

Korean games

MAGNA CARTA-The Phantom of the Avalanche
3D online RPG from Softmax Co. Its characters were created by Kim Hyung-Tae and have attracted worldwide attention for their graphic quality. *PS2* the Best is currently on sale. The character design for *The War of Genesis 3* was also done by Kim Hyung-Tae.

Ez2DJ
Successful music action game from Amuseworld. Its market availability has decreased since Amuseworld withdrew from the arcade game industry.

LINEAGE II
Online game developed by NC Soft Co. and operated by NC Japan. Its character design was created by Jeong Juno. The graphics are remarkably beautiful.

layer

Function that gives an effect of covering the image with a virtual film, it can consist of shades, translucent features, letters, and image-contrast adjustment controls, without influencing the original picture.

maru pen

Cylinder-shaped fine nib that writes with a very fine line, and is often used for detailing. Its flexible pen point is good for drawing contrast between strong and weak lines. Originally, it was called a "mapping pen," and was used for drawing contour lines on maps.